Steve Tobin
Reconstructions

Steve Tobin
Reconstructions

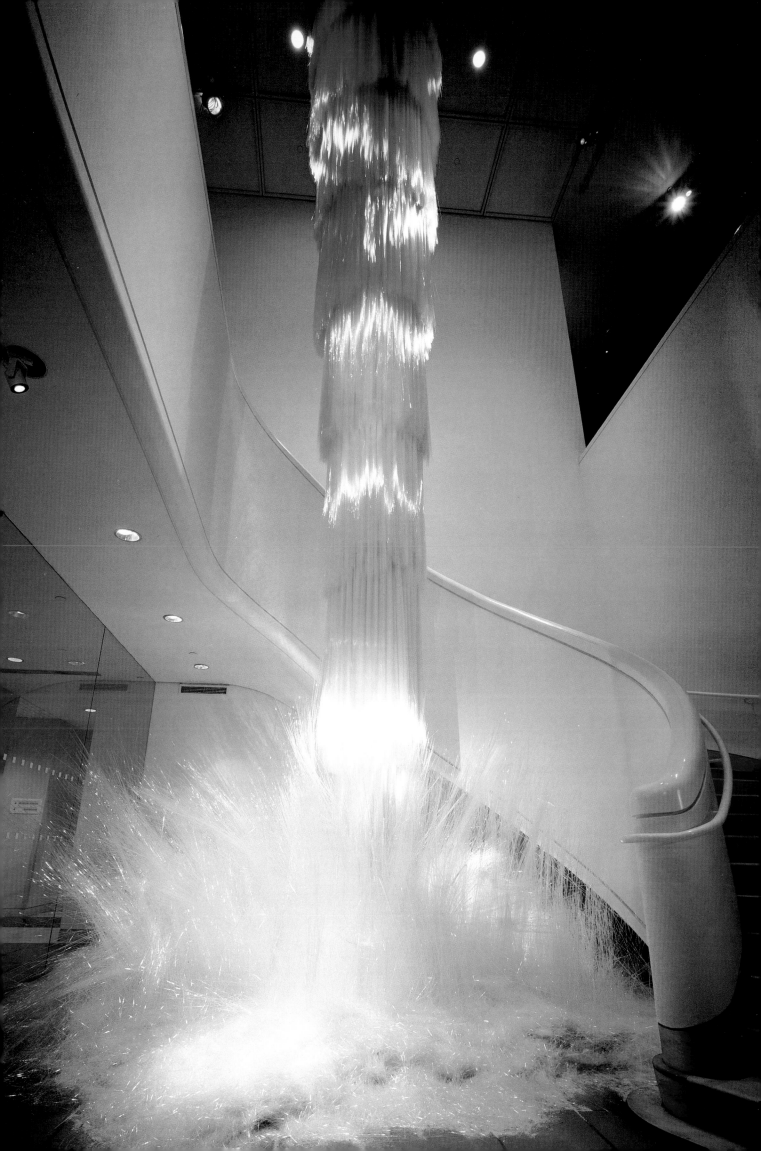

Steve Tobin: Reconstructions

Published by the Philip and Muriel Berman
Museum of Art at Ursinus College

©1995 Philip and Muriel Berman Museum of Art
at Ursinus College, P.O. Box 1000, Main Street,
Collegeville, Pennsylvania 19426

Introduction: *Lisa Tremper Barnes*
Body Statement: ©1995 *Karen A. Lodge*
Artist statements: ©1995 *Steve Tobin*

Design by
Christopher Rose & Andrew Rice, Kenai Design, Inc.
Boulder, Colorado

Photography by
©1995 *George Erml*

Printed by
Consolidated/Drake Press
Philadelphia, Pennsylvania

Electronic Prepress:
The Dot Ranch
Boulder, Colorado

Steve Tobin: Reconstructions
Presented at the Philip and Muriel Berman Museum of Art
at Ursinus College from September 19 to November 22, 1995

ISBN 0-9624021-9-2

Steve Tobin
Reconstructions

at

Philip and Muriel Berman
Museum of Art
at Ursinus College

September *19 thru* November 22
1995

Photographs
by
George Erml

Introduction

Steve Tobin has the work ethic of a journeyman which complements a creative vision that is articulated with directness, confidence and rooted in form.

I first met Steve Tobin in August of 1993 outside Allentown, Pennsylvania while on a tour of the L&M Fabricating plant with Philip Berman. He was directing a welder working on some steel I-beams, grouping them together like a city skyline. I departed with a catalog on the artist and wondered how someone who made his reputation sculpting glass, an elegant and precise medium, had turned to working with heavy, rough, industrial by-products.

The reason was simple; an opportunity was presented and Tobin seized the chance to expand his artistic and technical expertise. Muriel and Philip Berman sponsored an intensive, three week workshop for sculptors in 1993 and invited Tobin to participate. He had achieved success as one of the foremost glass artists in the world and had decided to turn his energies towards music. The Berman workshop offered more tangible, and immediate rewards in the complete freedom to work in a new medium without distraction.

Of the abundance of material made available to the sculptors, the steel I-beams-rusted remnants, ends melted and curled - attracted Tobin's attention and his work focused on re-inventing their function. Whether grouped together like falling gravestones or isolated, ram-rod straight and topped with a block of granite like a solitary figure, the transition from functional, obscure support elements to dynamic, primary forms proved an evocative challenge for the artist.

At the conclusion of the workshop Tobin continued to work with the large I-beams and began to experiment with bronze casting. The idea of using found objects is a critical element in Tobin's work of the last two years. Scavenging, recycling, trading and flea markets have become the source of his raw material. He has turned surplus tank windows into a prismed adobe hut. Animal bones have been cast in bronze and manipulated into orbs, arches, and undulating walls. Children's toys, women's shoes, and garden fresh vegetables have been frozen in bronze to create thoughtful compositions.

Tobin's studio, housed in a converted Pennsylvania barn, is always alive with activity. His home and surrounding land serve as a garden for works in progress and completed sculpture. Tobin orchestrates his crew, all artists themselves, in a manner that is both efficient and demanding. While music blares, heavy cauldrons of molten bronze are lifted, carried, and poured under the watchful eye of the artist. Tobin keeps up the pace of this hot, grueling work for days on end. His crew is his support structure and they are as committed as Tobin to achieving a high quality of technical production; however, the composition and life of the object comes solely from the artist.

"Steve Tobin: Reconstructions", a body of work on exhibit at the Philip and Muriel Berman Museum of Art at Ursinus College during the fall of 1995, brings to fruition two years of immersion in metals by the artist and his dedicated team. The evolution from glass to steel to bronze is juxtaposed in the installation. There is a sense of completion in Tobin's interpretations. This aspect of the creative process will take Tobin to a different level and, perhaps, to a different medium.

It is an adventure to work alongside Steve Tobin. The energy, enthusiasm, and skill he brings to his art is only matched by the zeal with which Muriel and Philip Berman have encouraged the artist to test his limits. It is a pleasure for me to be associated with them in this project. The Friends of the Berman Museum of Art provided their endorsement and support for this exhibition and I thank them for their many contributions.

Lisa Tremper Barnes
The Muriel M. Berman Director
Philip and Muriel Berman Museum of Art at Ursinus College

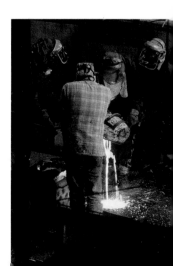

Good art transcends time and cultural boundaries. In our century alone, art and artists have completed the separation struggle of three hundred years, no longer necessitating exclusive ownership by royalty, and finally released from the shackles of requiring a theological or mythological influence in the creation itself. More specifically, we can look to art in the twentieth century as the direct reflection of the persona of individual artists and their cultural influences.

Since the beginning of his career, Steve Tobin's work has been closely defined by the themes of nature and found objects. From the inception of his cocoons in 1984 at Wheaton Village, through the casting in glass of the sensual forms of the human body, the artist has emerged into a philosophical re-ordering of the universe by using these refused objects in a collection that spans the energies of only two years.

In a continuing attempt to introduce political and social statements into his artwork, Tobin began resourcing the refuse he finds obscuring our environment. In doing so, Tobin gathered the components from which he has created a dynamic and intuitive re-actualization of nature and man.

Each object used in Steve Tobin's creations had a life prior to its reincarnation in his studio. Tobin views life reduced to its barest forms. His ideas originate in the components themselves...A body, a human, all humanity and social structure begin with one skeleton, one bone. A building, a city, a country, the physical structures on our planet, begin with the support of one steel I-beam. The practical use of each component is obscured by the art process. An improvisational evolution, giving second life to discarded objects, begins to take place. A new nature is born.

The *Toy Bronzes, Bone Sculptures, Steel Reconstructions, Water Glass* and the *Adobe* are the culmination of Tobin's personal revelations reflecting on found objects, exemplifying the information in structures and patterns in nature. Tobin is suggesting that people observe more closely these objects, cast off by humanity.

Tobin's efforts are philosophically directed at stripping away the layers of socialization that have accrued on mankind...to point out the numbing ideology of our times and how it has woven veils over our eyes. What we do, what we use, what we discard.... these varied relationships are predetermined for us through the socialization process.

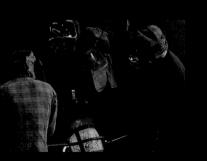
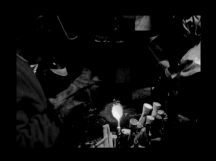
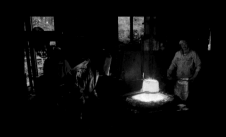

"We can no longer see what we have become." Tobin is attempting, through his creations, to point us in a direction closer to the simple event of living.

Tobin's sculptures often begin with a singular module. Once these paradigms of nature are combined through deliberate imagery we can experience the artist's metaphysical inter-relationship with the event of living. The event itself becomes the only truth.

The *New York Column* and *Palm Beach River* are constructed entirely out of discarded glass tubes. Tobin utilizes these cast off modular units to create the expression, passion and context of falling, flowing water. The translucence of the glass invites the viewer into each illusory creation.

Steve Tobin respects an I-beam as an object powerful and beautiful in its raw and intended function. Void of analysis or explanation, each one has its own history. To him they are the discarded basic building block of society. *Homage* has patterns of circular, jutting steel. The steel parts are an emanating, dissemination of power. In Tobin's *Homage* the larger pieces are positioned in the center, the remaining I-beams are leaning toward the large ones as a gesture...of *Homage*. The entire meaning of the composition is intended to elicit a primordial perception of placement and gesture.

The *Adobe* is a shelter-like structure created out of seven hundred and forty scavenged M-60 tank windows. The strength of the laminated glass can be felt by the captured bullets fired randomly into several of the windows, fracturing, but not penetrating the glass. The *Adobe* has a parabolic shape that transforms light, sound and space creating reflections and echoes. It is disorienting visually and acoustically. The observers can feel the mass of twenty-six thousand pounds of sculpture around them.

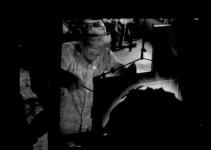
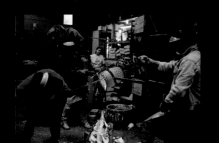
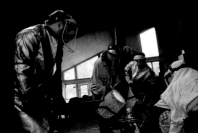

Naming the bronze sculptures *Toy Bronzes* has the effect of disarming the viewer. Many components of these sculptures are collected as cultural artifacts and are molded directly from toys. Tobin is commenting on the use of toys in our culture as tools for socialization. They are an objective way to sample the socialization process.

The *Buddha* series combines the body of a Buddha with different animal heads. The head varies from a tiger's aggression, a giraffe's tranquility, to the innocence of a baby's head. Tobin expresses the nature of spirituality in each of these elements. By binding the spiritual essence of each of these animals with the pursuit of the spirituality of man, the artist reveals his sense of the hierarchy of nature over man.

Noah's Ark inspires thoughts of where we are currently located in the evolution of man. Extrapolating backwards to the time of the ark, we can imagine what might have occurred during its voyage…the various religions, figures, aggressions and pathos. When viewing Tobin's bronzes we are entreated to think with a deeper passion of the condition of mankind, removed from the space of time we are inhabiting. It is Tobin's attempt to objectify the chaos in which we live.

In contrast to the other *Toy Bronzes* are the *Shoes* and the *Fish*. The *Shoes* are still lifes, simply displayed as one might find them in the closet. It is the desire of the artist that the viewer see the things we wear and the foods we eat as current cultural artifacts. High-heeled shoes and dried fish may not survive the next millennia, but they are as culturally rich as any art or artifact of our time. Tobin is taking objects as artifacts from our culture and preserving them as icons for the future.

In opposition to the I-beams and bronzes are the *Paddle Sculptures*. The *Pinecone* and the *Sunflower* are industrial artifacts transformed into a new nature. A portion of each geometric interior is left uncovered to reveal the organizing symmetry almost obscured beneath the organic array of paddles.

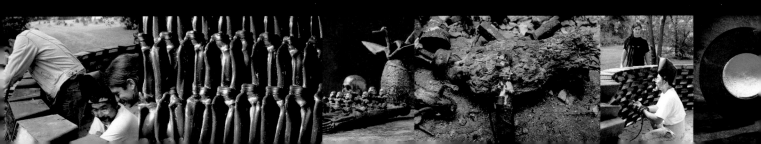

Tobin sees beauty in the strength of the structure of bones. Each shape and transition of shapes is created out of structural necessity. The architecture of the body is translated into the shape of each bone. The bones are the basic building blocks for all animalkind. In Tobin's *Bone Sculptures* the bones are reborn, re-combined into new shapes. As your eye moves from bone to bone there is always somewhere else for it to go, then come back again at another angle, the sculpture recreating itself in a kind of infinity.

By taking socially and culturally acceptable, identifiable forms...a discarded toy, found capillary tubes, a tank window, an I-beam...and re-associating these objects into his own symbols, Tobin invites you on a journey to the portholes of a new vision. Through his use of the discarded refuse of modern society, Tobin recreates a new nature, conceived in glass, bronze and steel.

In utilizing universal images and ideas, Steve Tobin summons the viewer to delve into the mystery of each creation. The questions are yours to decipher, for Tobin declines to answer the 'whys'.

Tobin's messages are spiritual. They are political. Each creation is emotional, evocative and intriguing on a vast level. It is the filling of a void for the artist where he sees a lack of justice, a lack of order in society. Tobin's work is his reaction to life as he views it.

Steve Tobin's creations are a relief to the weary art world. He perceives himself as one who does not allow his demons to possess him...they may simply pull the cart. No boundaries are acceptable; not size, not form, not medium. It is through sheer diversity of images, materials and concepts that Steve Tobin has earned his position as an important artist in our time.

K. A. Lodge

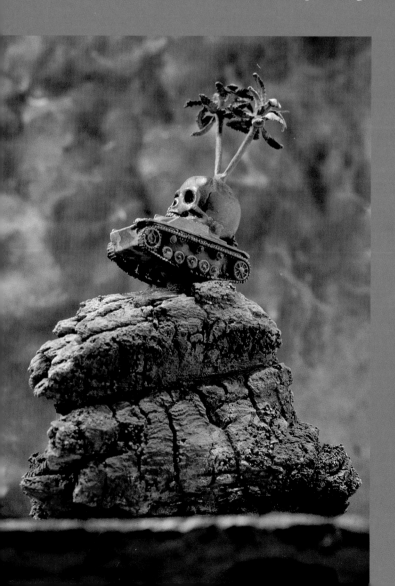

"*Seeing each individual familiar component combined into an unexpected combination jolts the viewer into re-examining or re-experiencing the components. Vegetables that we eat, toys that we play with and shoes that we wear are not seen as cultural artifacts. The irony is that these objects are based in the now. The fact that these vegetables and toys only last a few days, precludes us from experiencing them as a reflection of our culture. But when they're converted to bronze combined in this unusual, to the point of, shocking way, it makes us perceive each one as a cultural artifact.*"

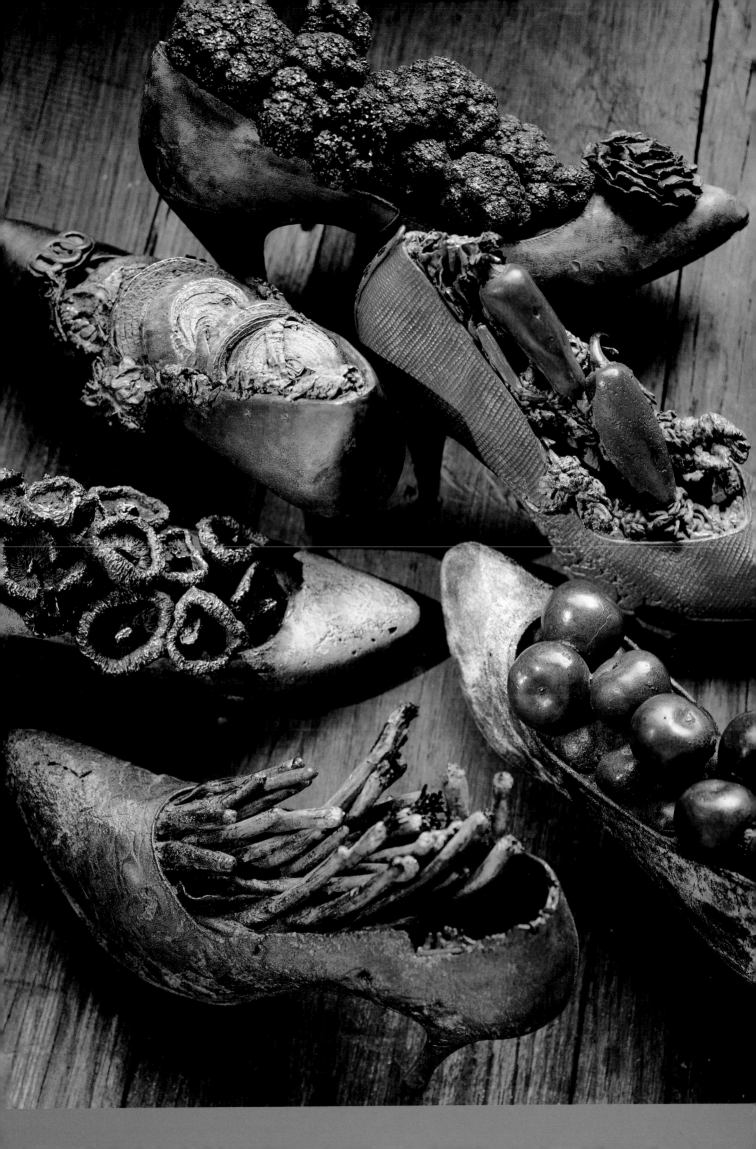

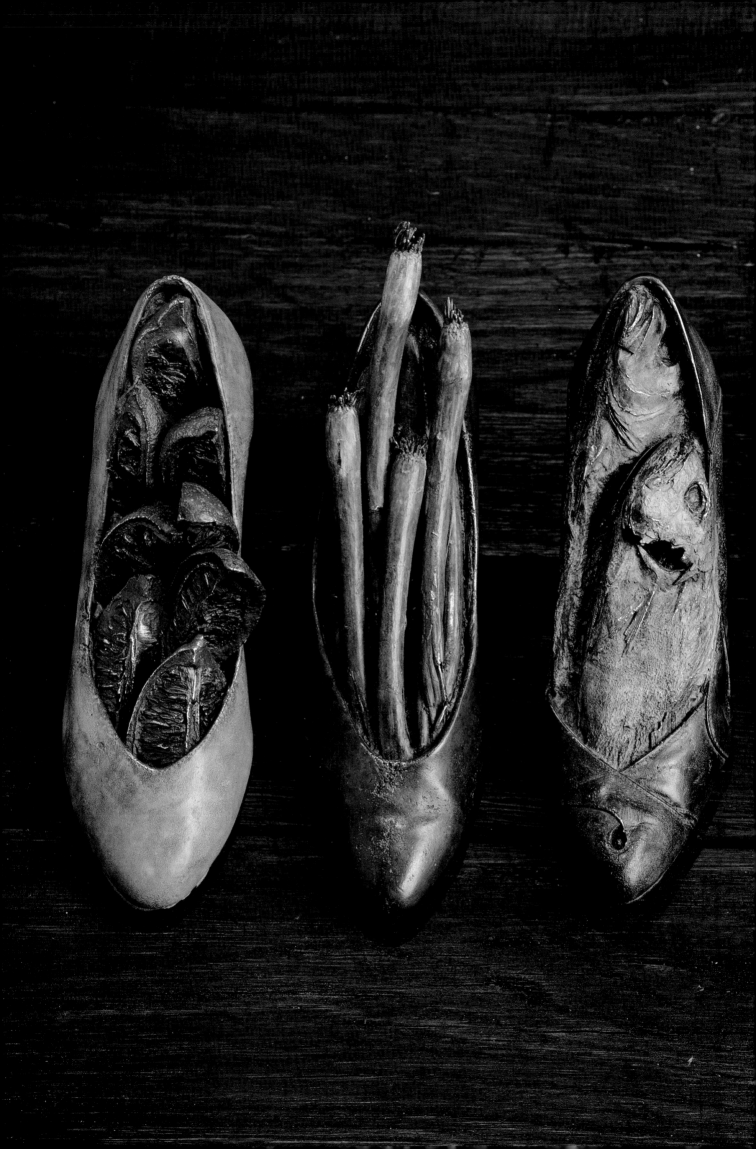

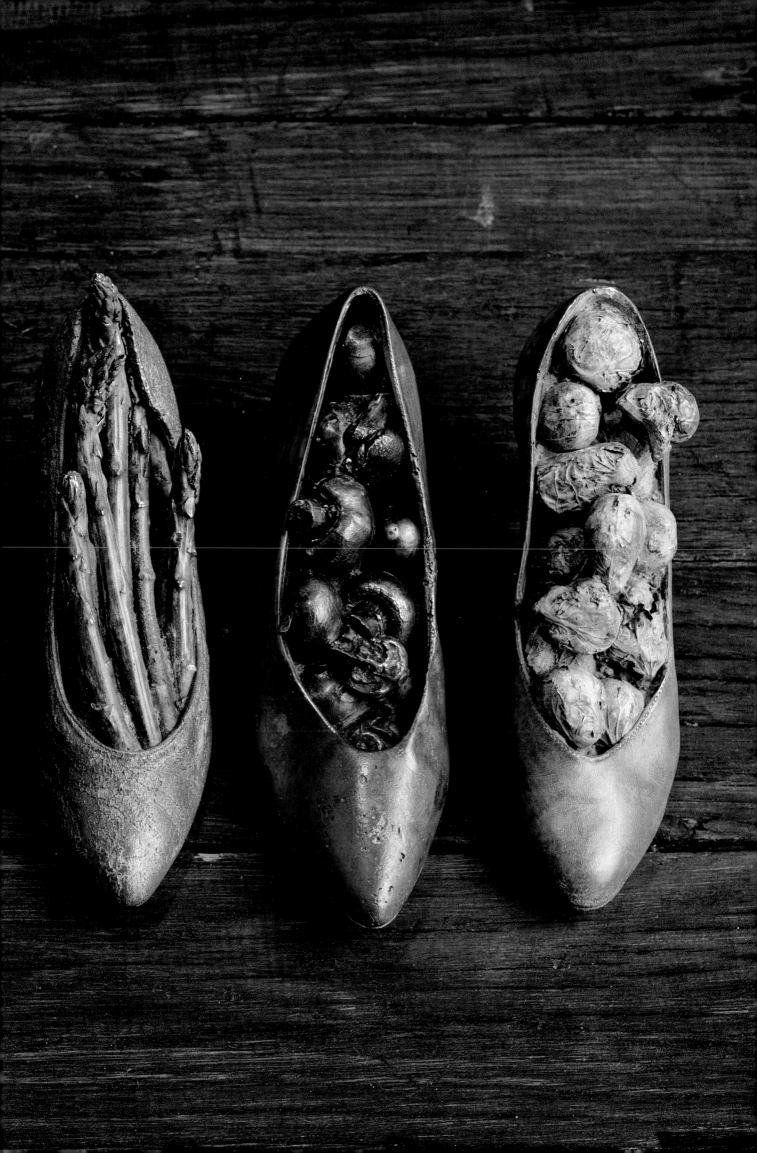

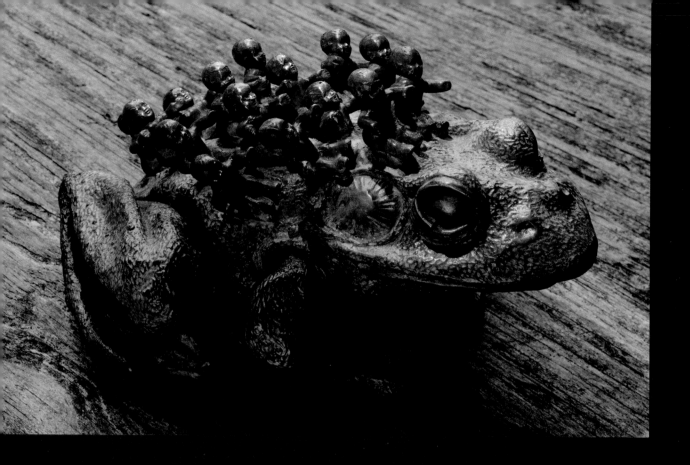

"Art is not just about making objects. The object created is a
souvenir of the art process. Art happens in the formation of an
idea and the maturation of this idea. For me, the art is the
personal, emotional and mental growth that occurs as a result of
realizing an idea. The object that is created only documents this
growth. So, art for me is a multilevel experience. There is a
mental creativity which conceives an idea. There is emotional
creativity which reflects personal feelings and emotions. And
there is physical creativity which is the intuitive expression of
the body."

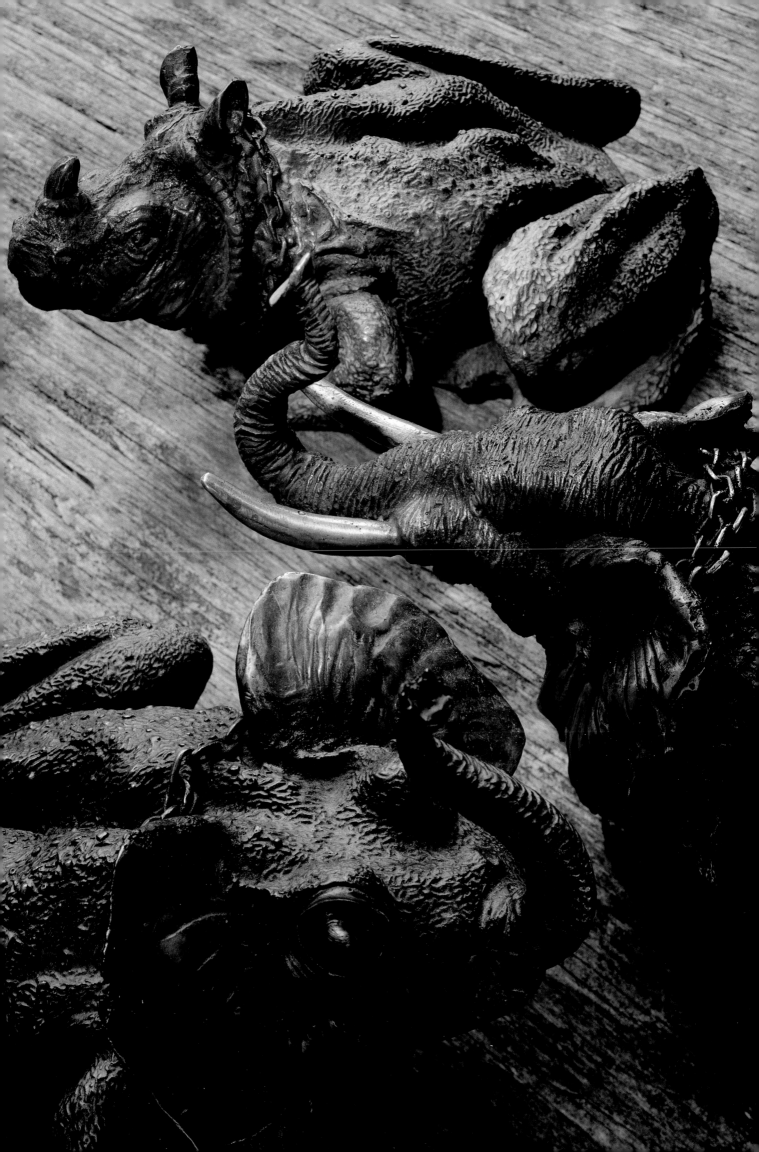

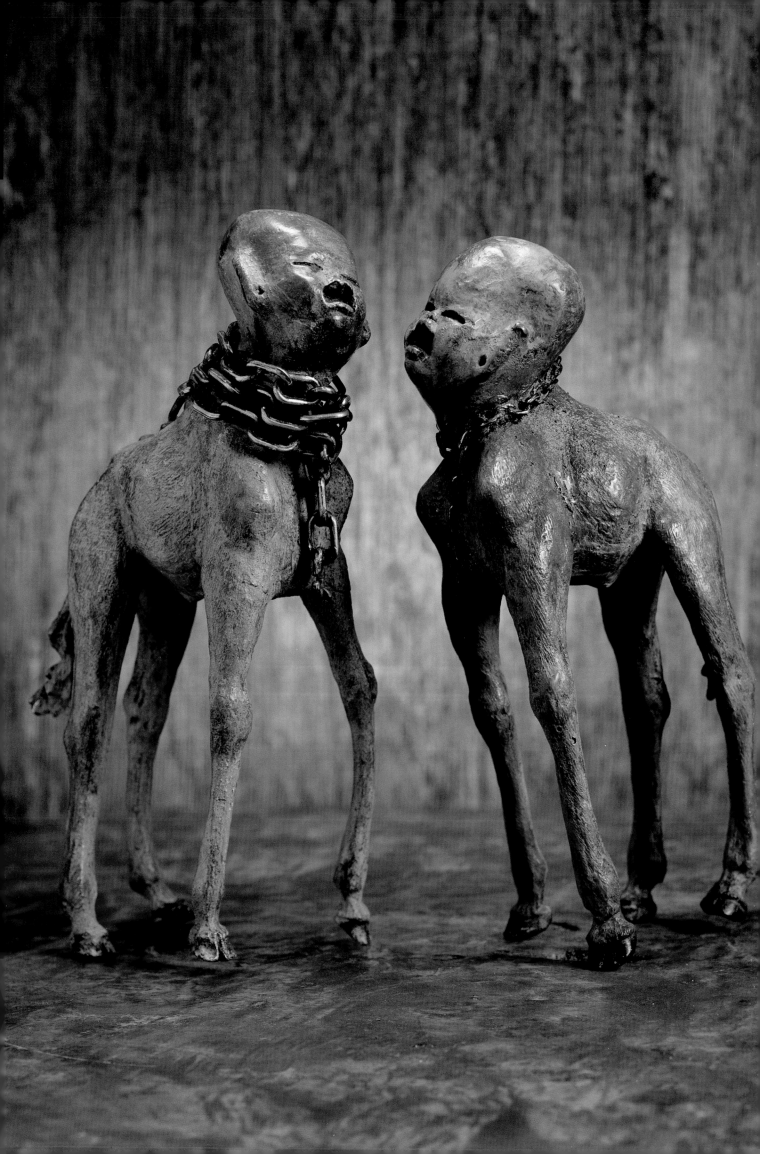

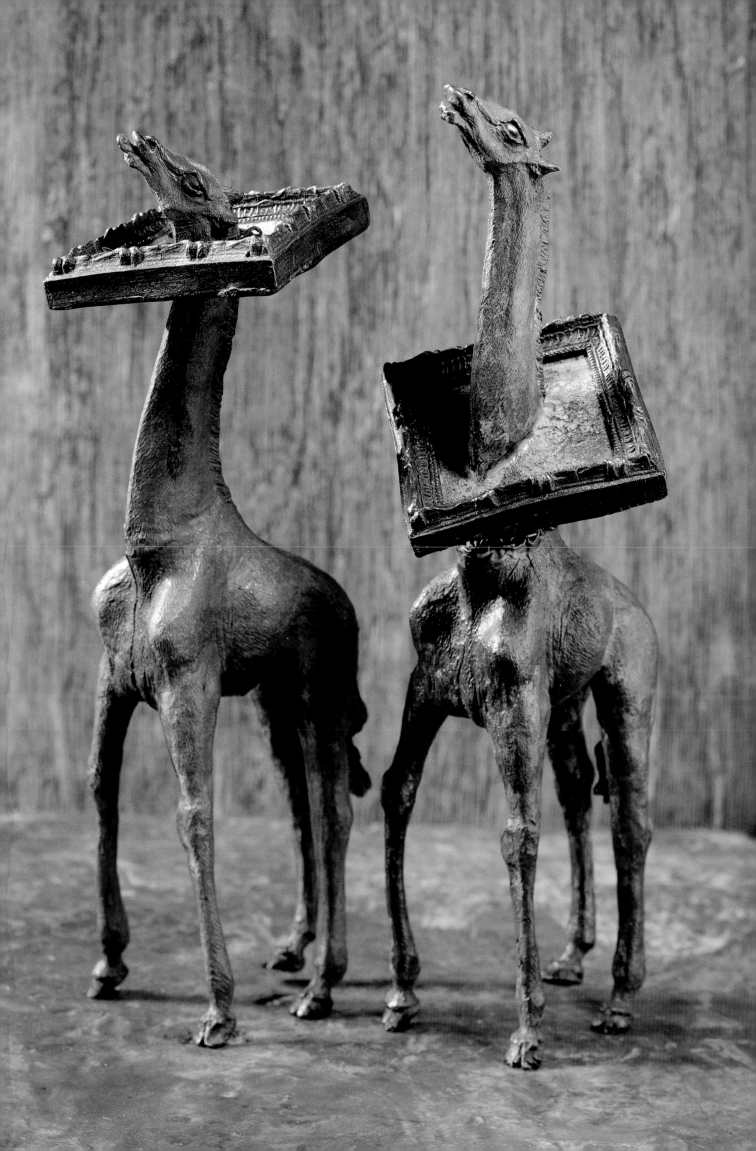

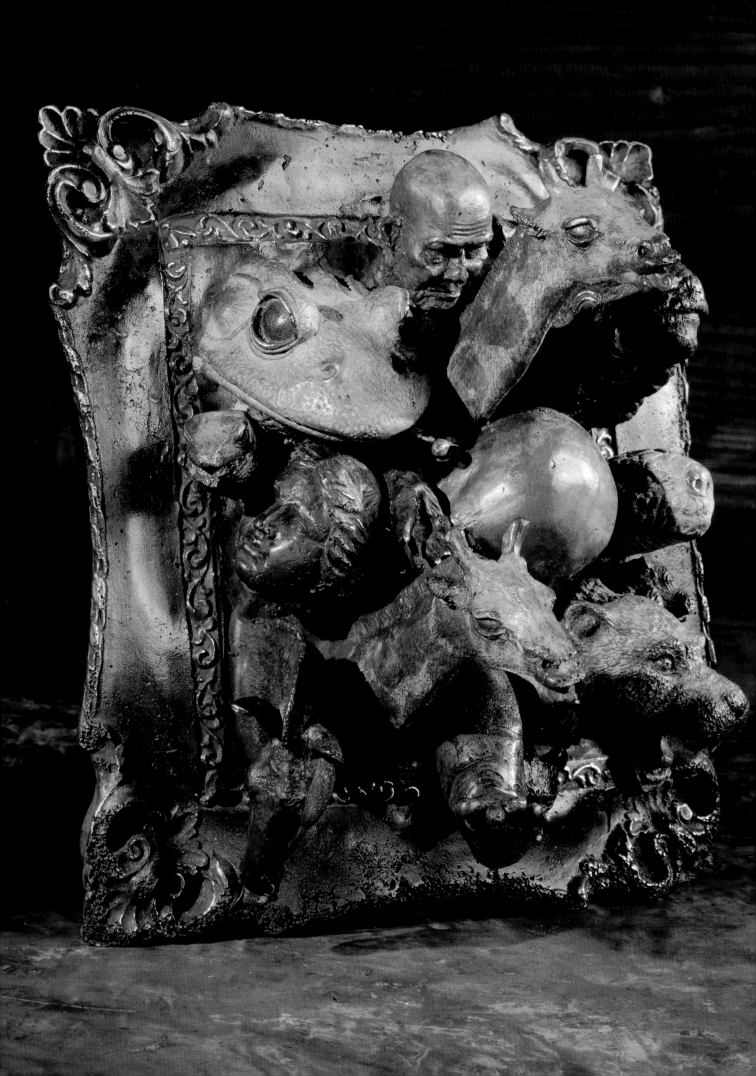

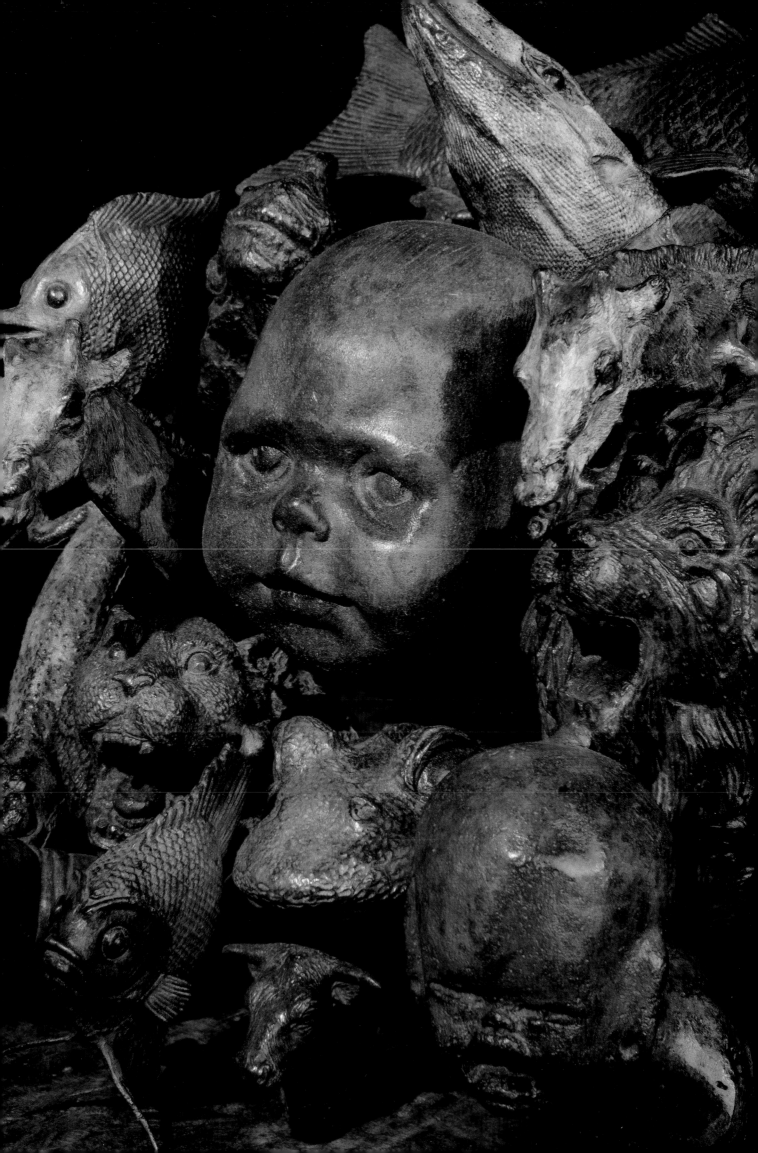

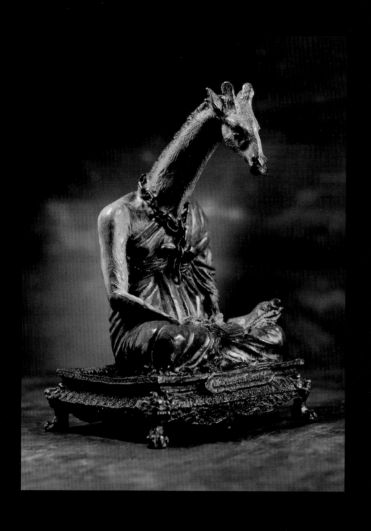
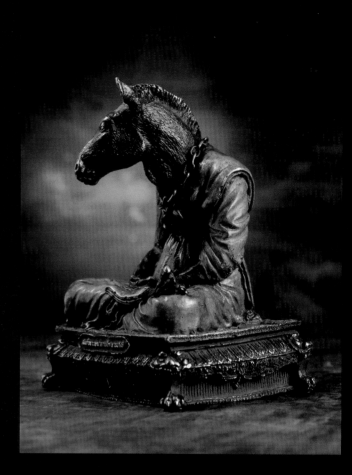
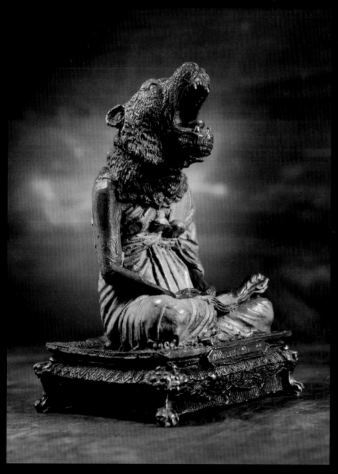
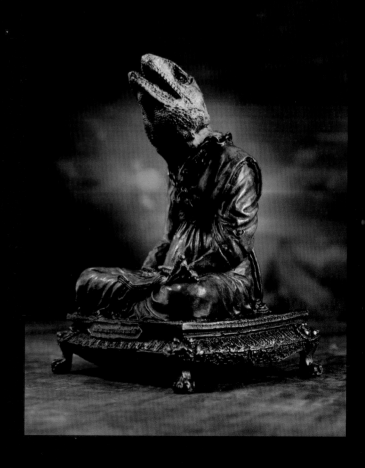

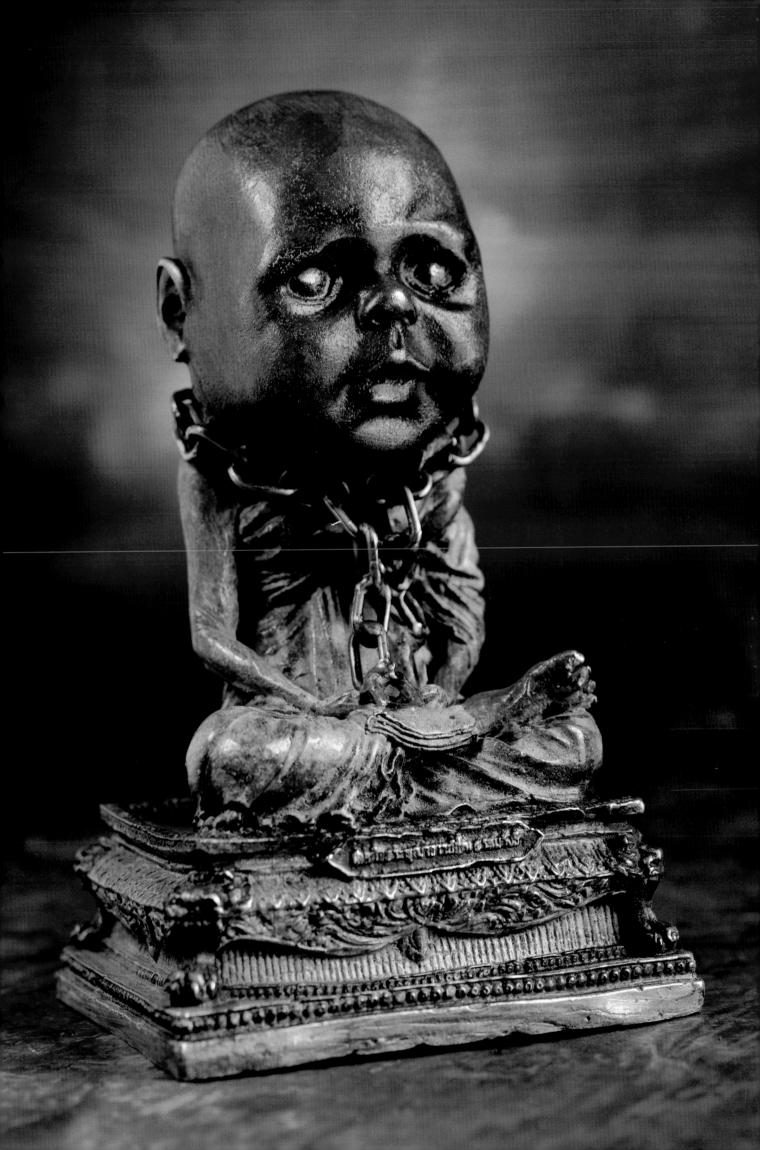

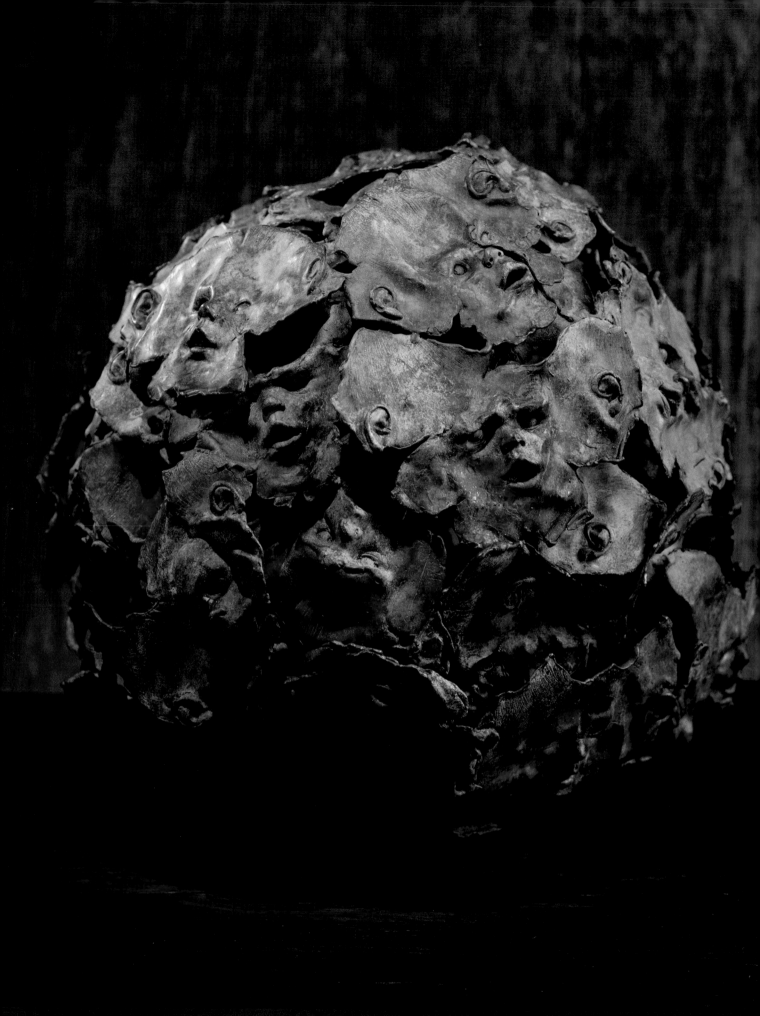

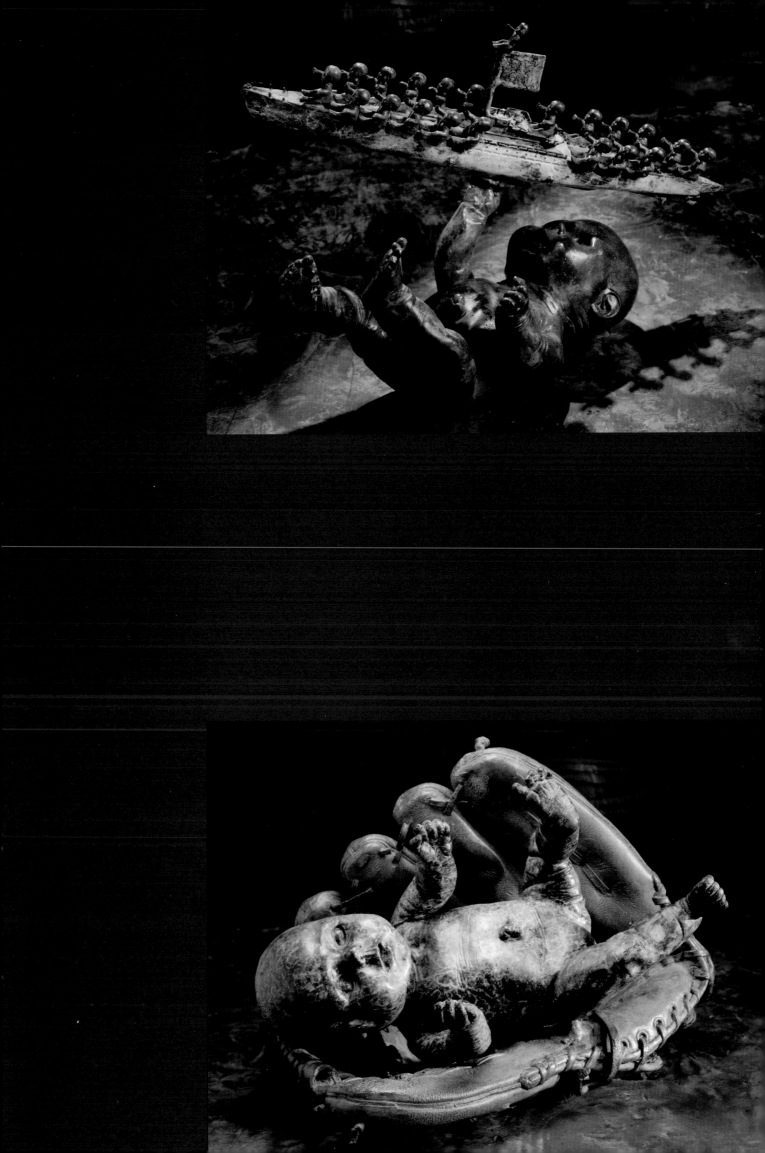

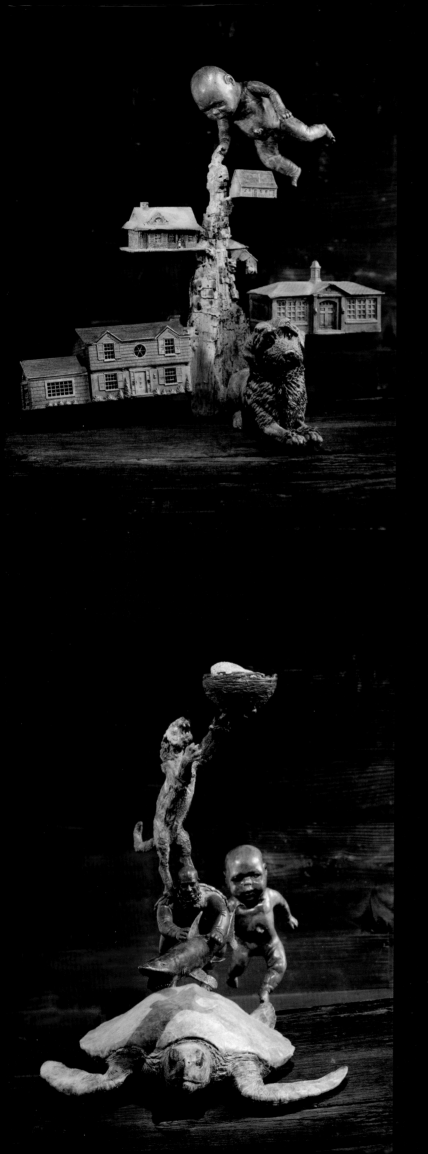

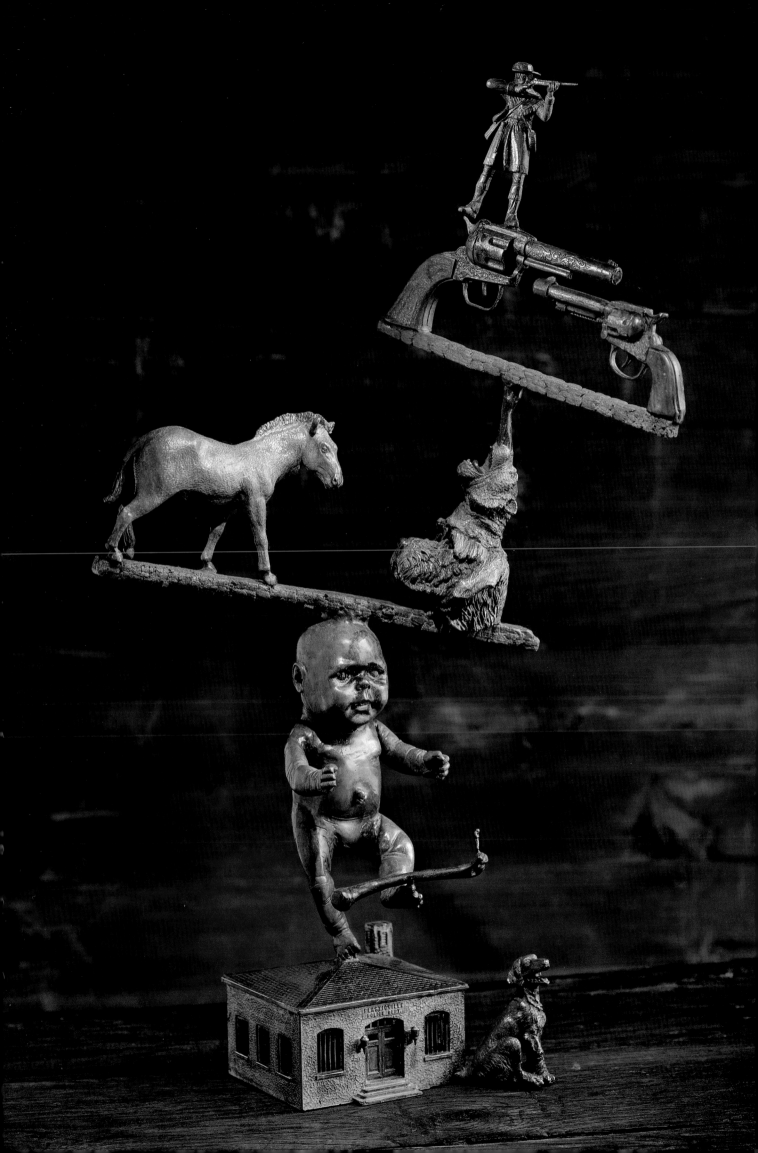

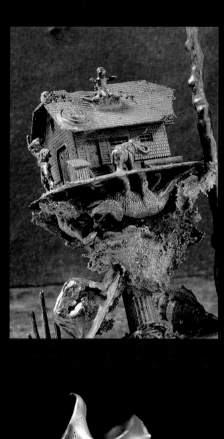
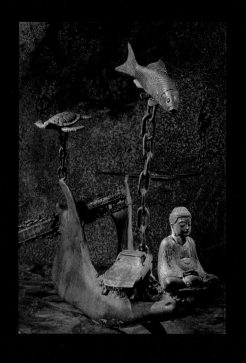
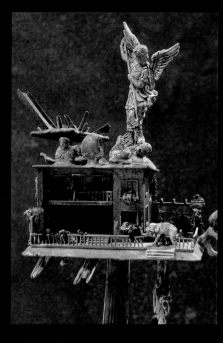
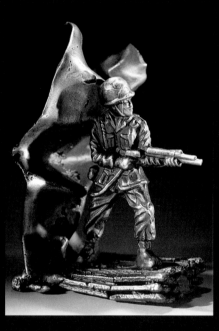
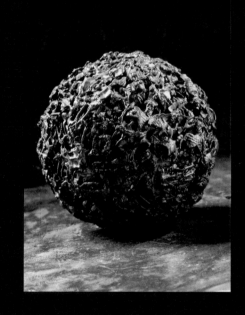
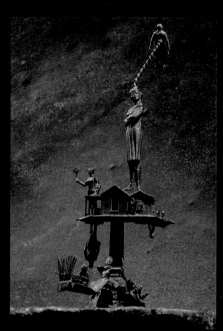
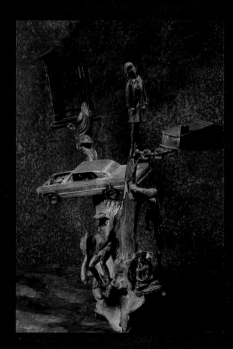
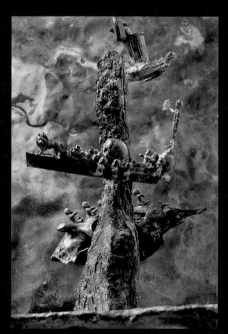
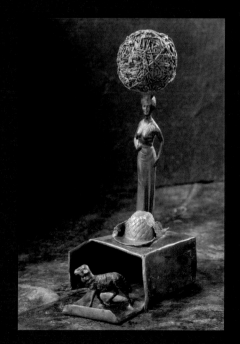

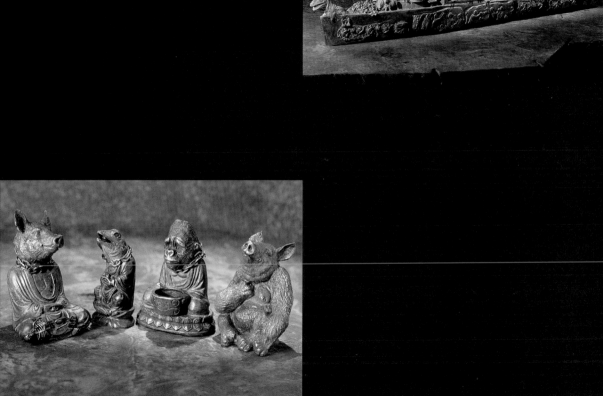

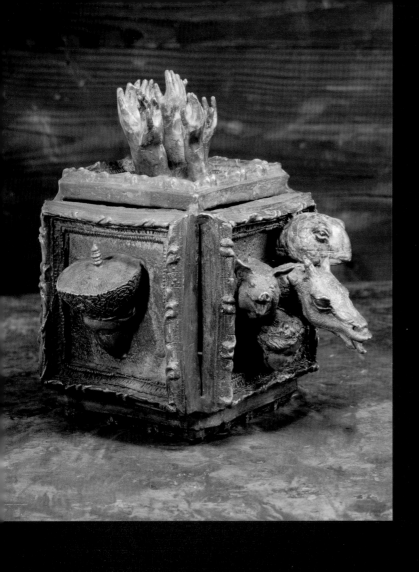

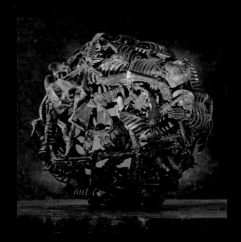

"There is no objective reality for mankind. There is only each person's observation of the universe which becomes an individual personalization of the truth. Our culture is moving towards a scientific definition of the universe. There are other equally valid alternative models to help us understand the universe. Science, philosophy and art ask and answer the same questions using different language."

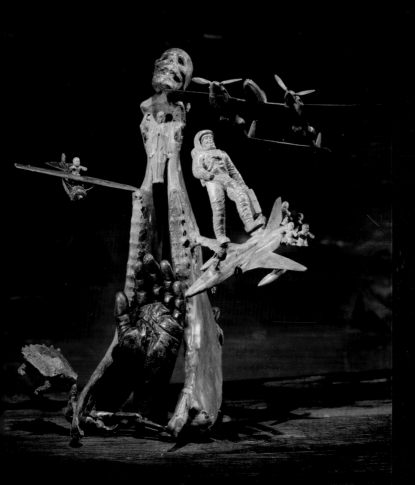

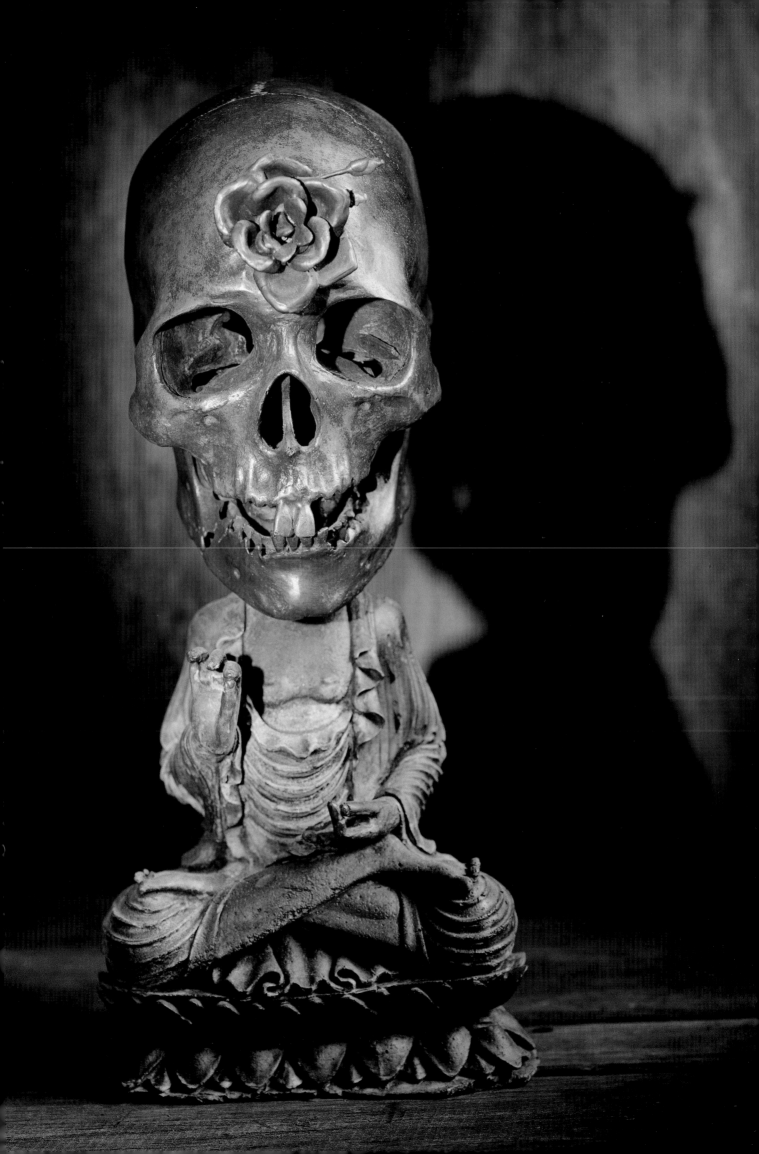

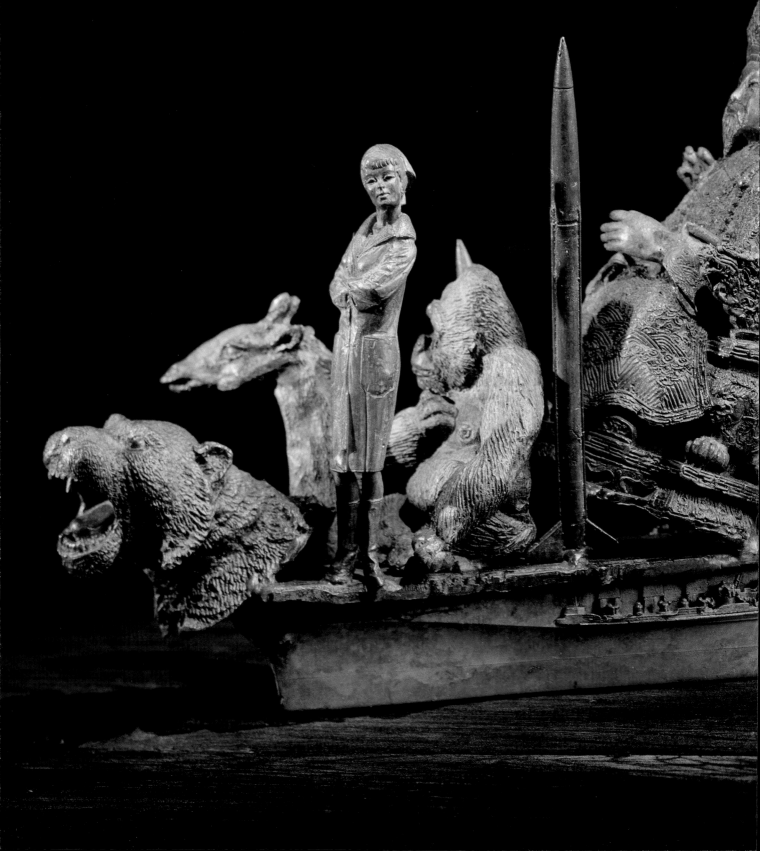

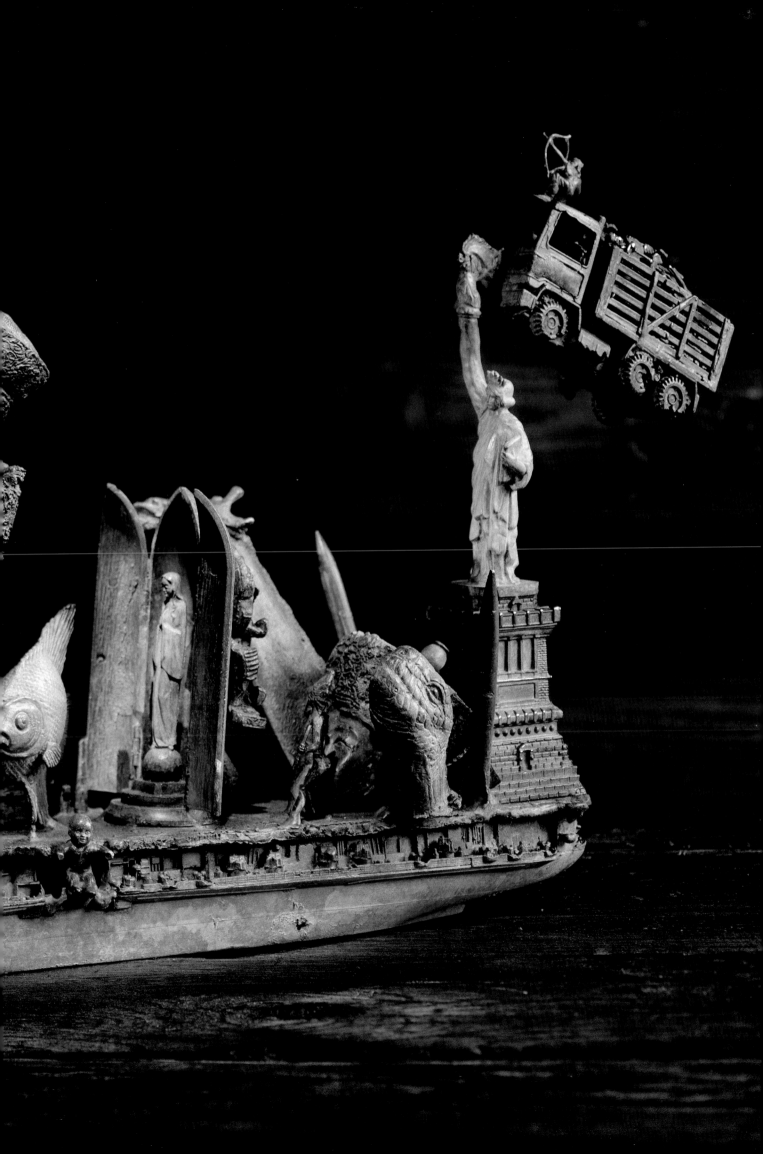

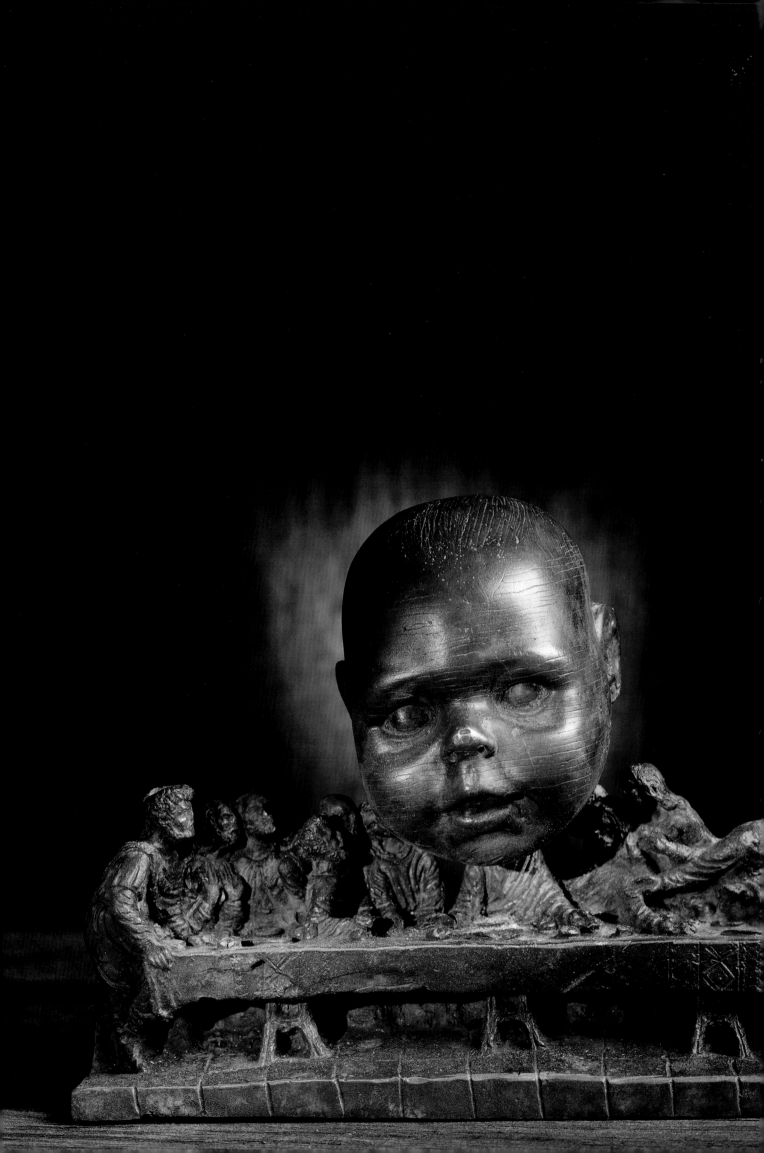

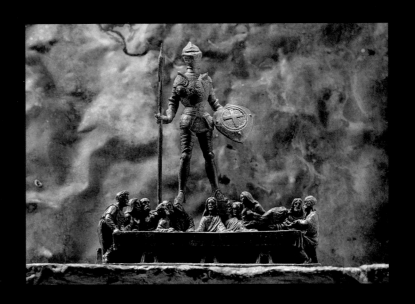

"If for one instant I can catch the viewer
off guard with my presentation, the effect
of the work may enter their subconscious
before reason dissects it. By dramatically
impacting or assaulting the viewer with
the presentation I can throw him off
balance and move his mind and emotions.
For that fraction of a second the unreal
becomes real. Once this door is opened it
can never be closed."

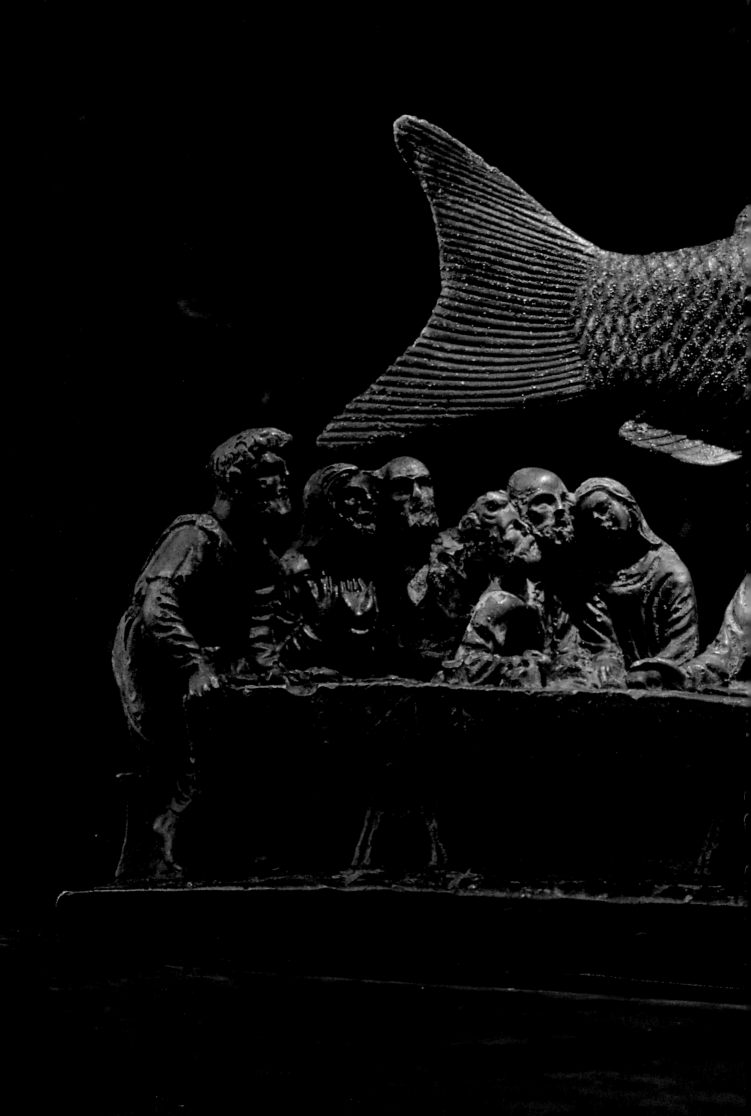

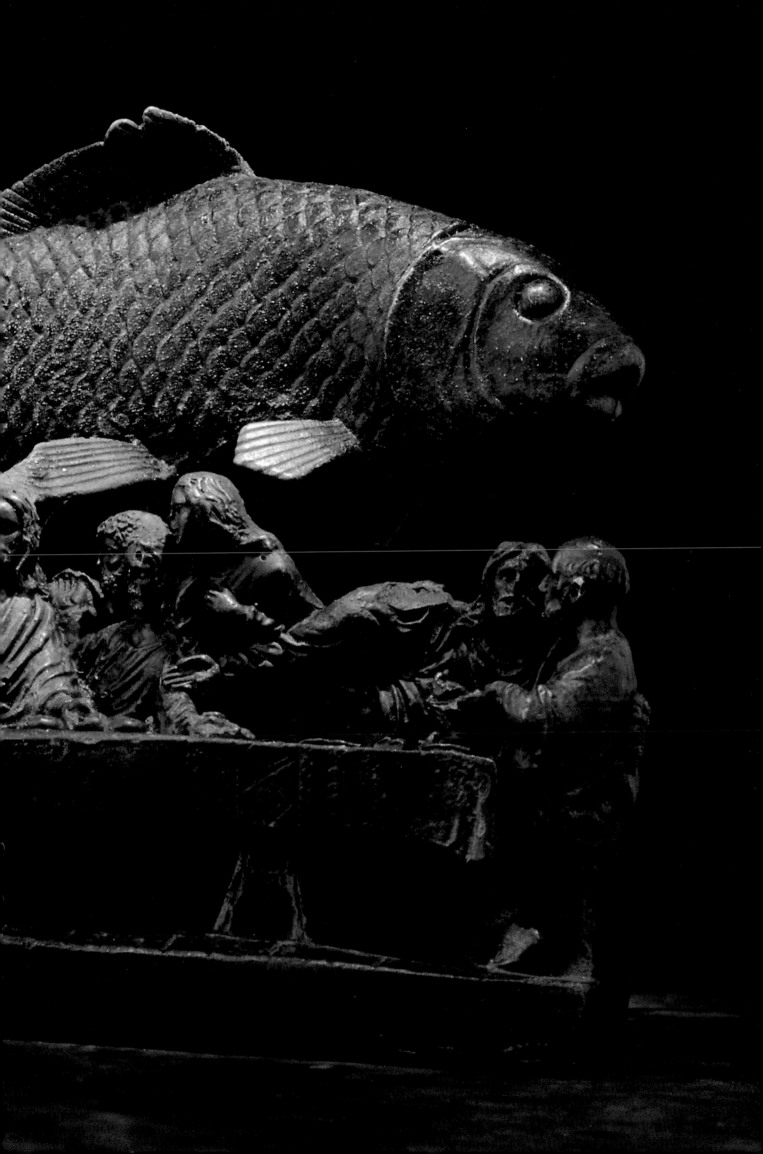

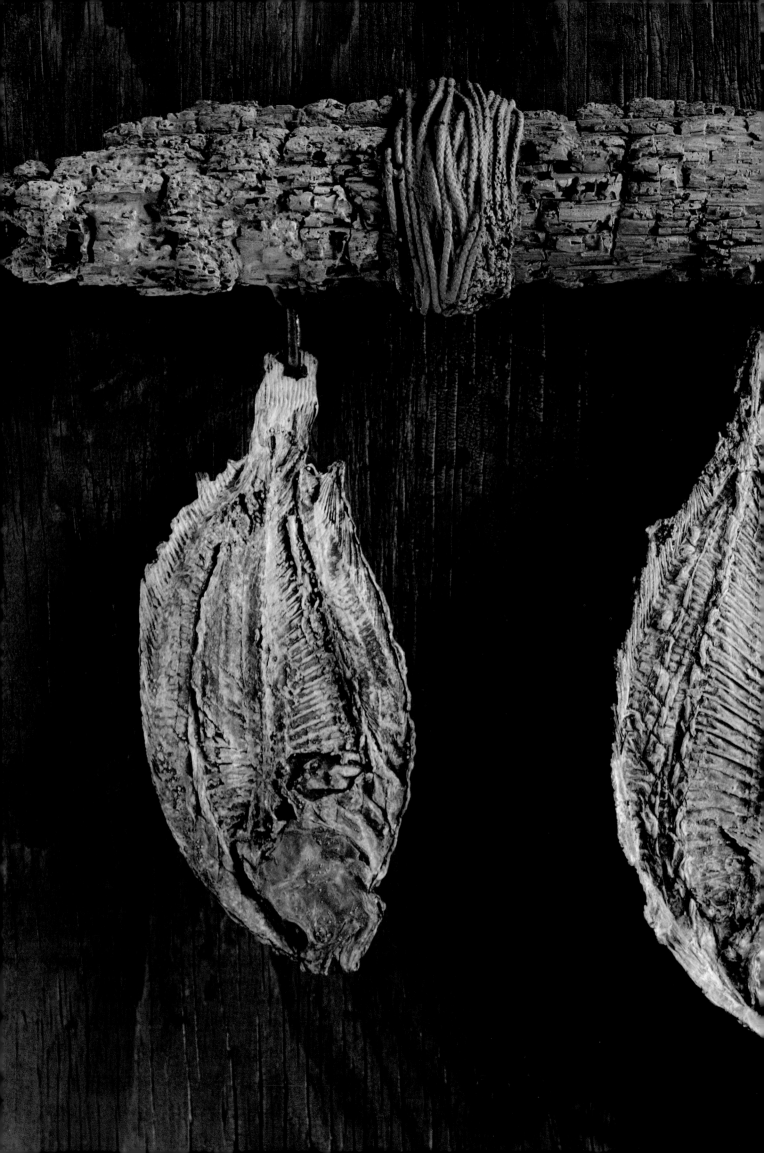

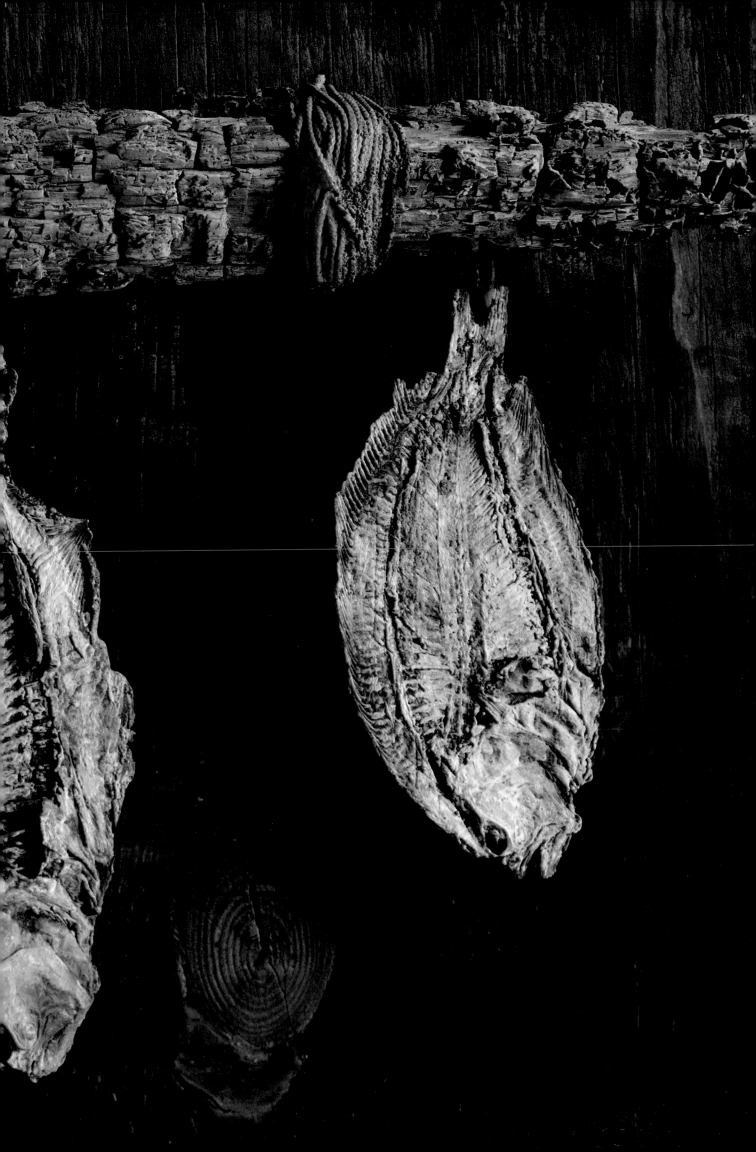

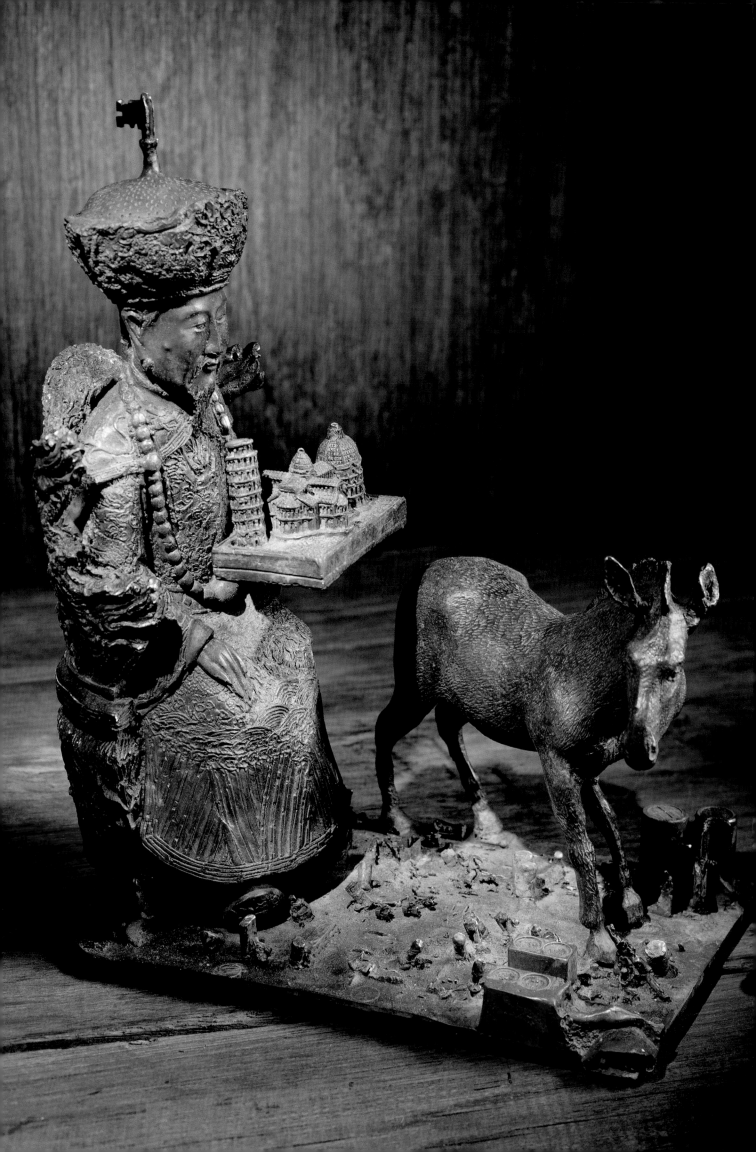

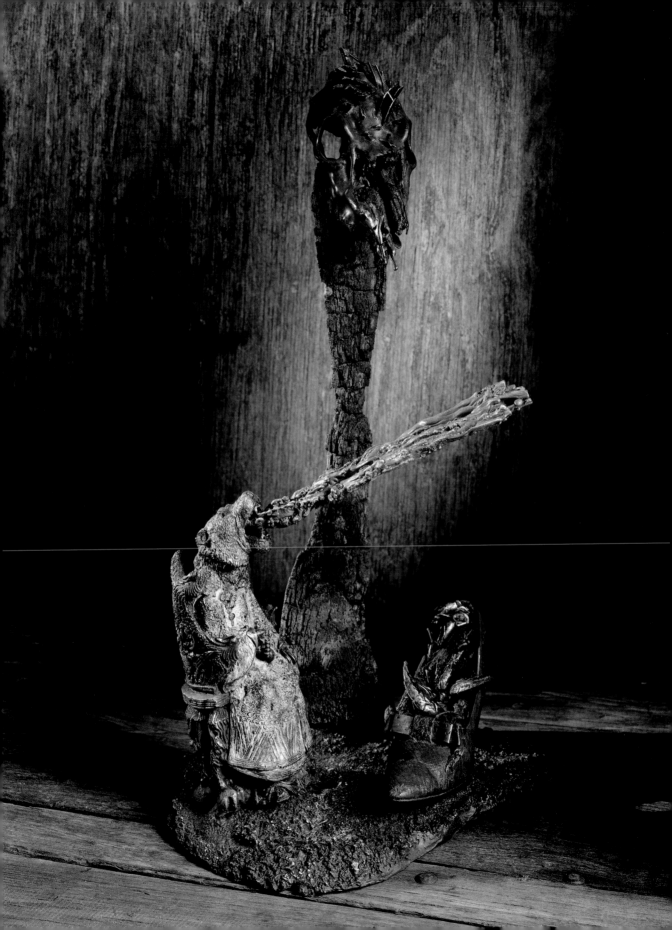

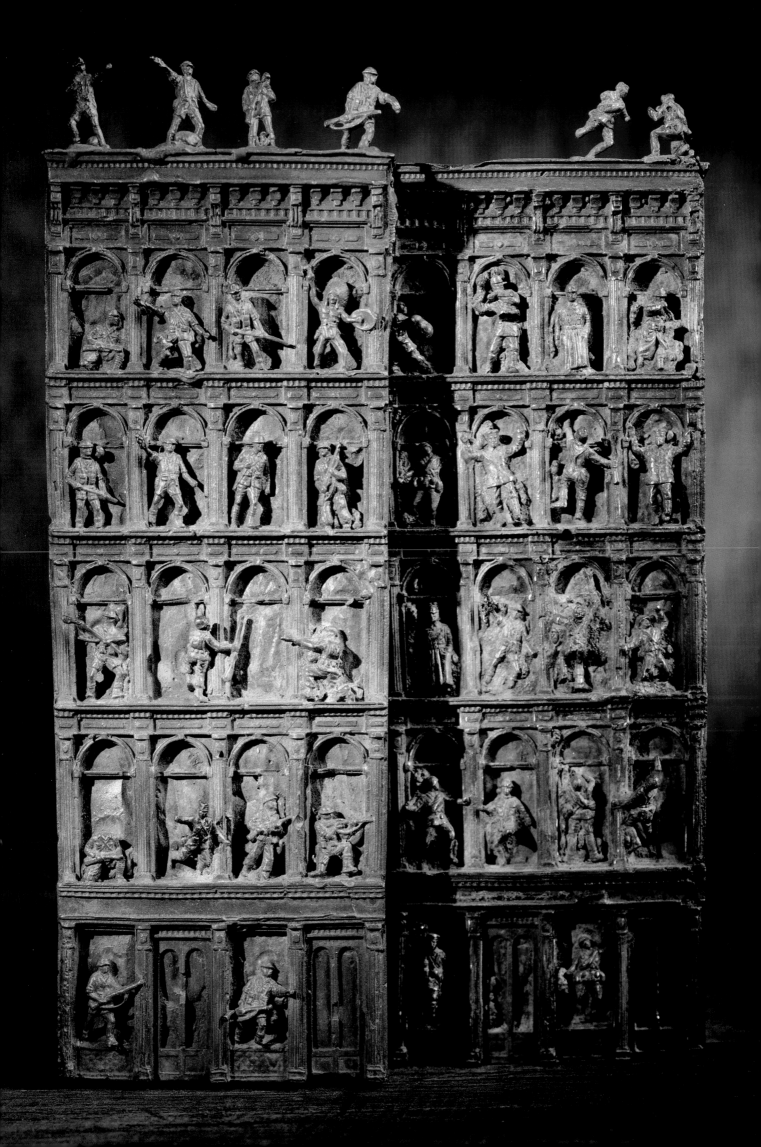

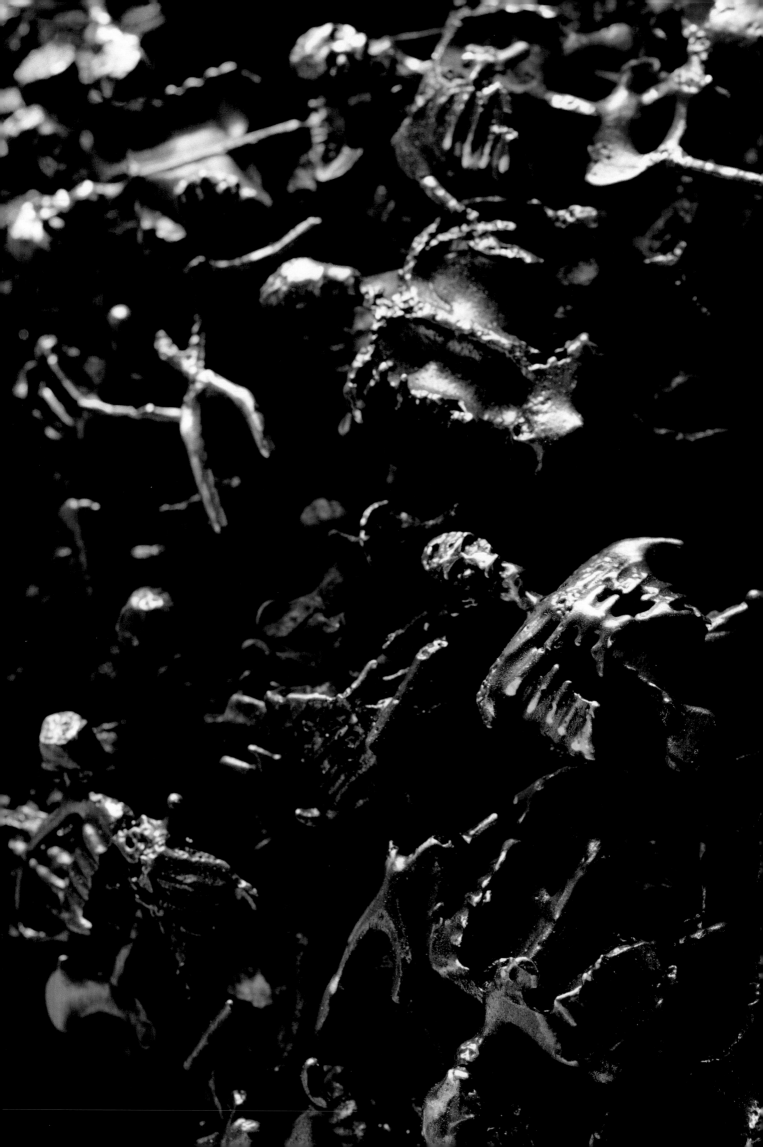

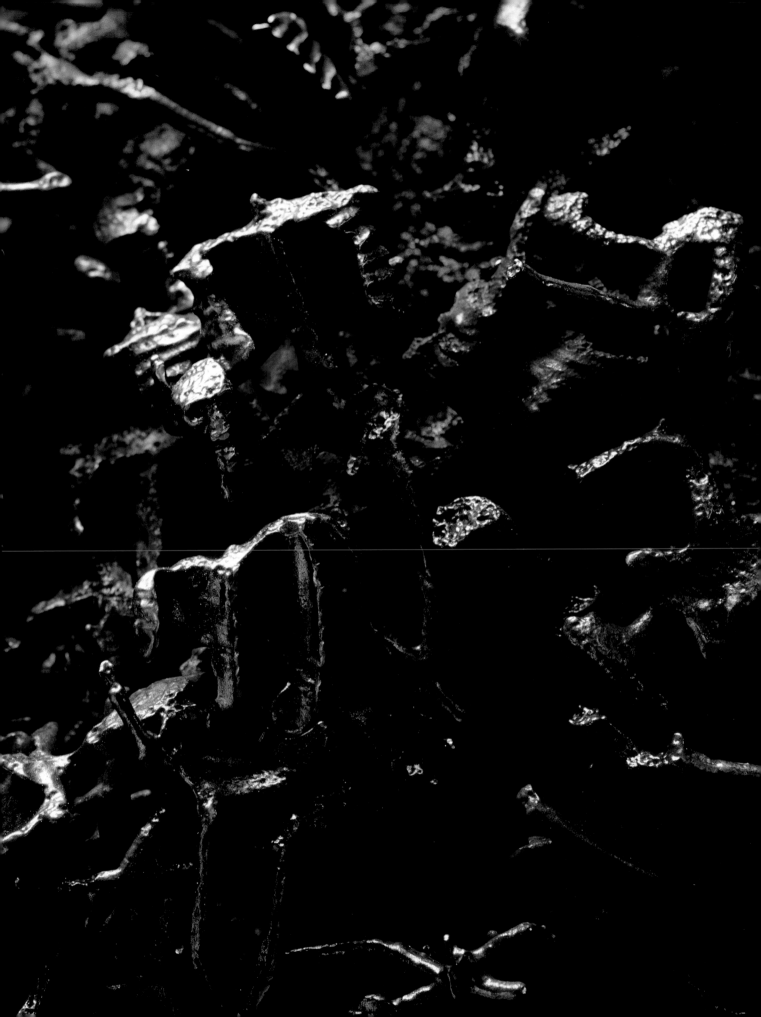

"Our universe is a subdivision of order within a whole system of chaos. Our solar system has order, we have physical laws...the movement of the stars is an ordered event. On our planet, where everything is reacting to physical laws there are many subdivisions of disorder and chaos."

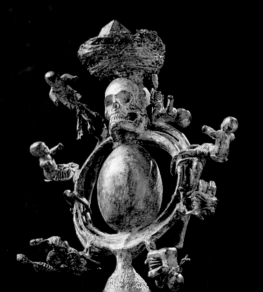

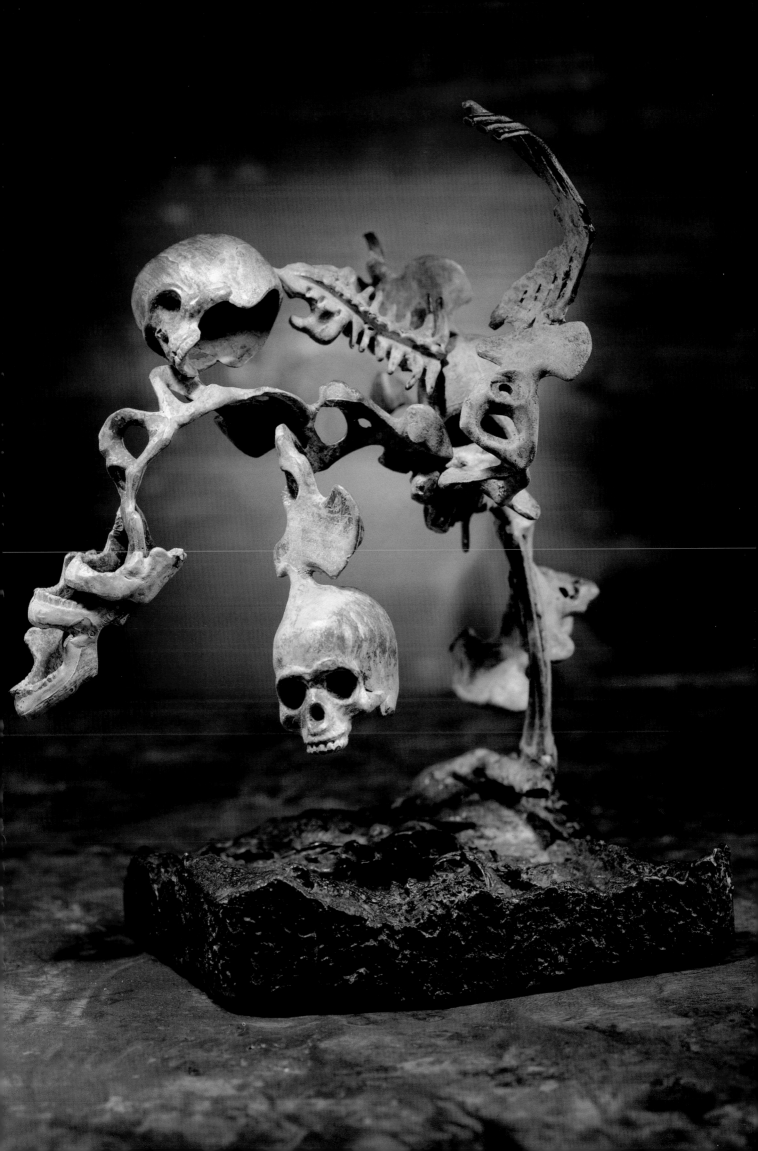

Adobe

"Many ideas come to me completed. Usually if I can completely 'see' a piece in my mind, then I don't feel compelled to make it. I make about five percent of the mature ideas that are formed in my mind. I feel most driven to make the pieces that are beyond my ability to fully understand. Often it will take me several years to complete an idea."

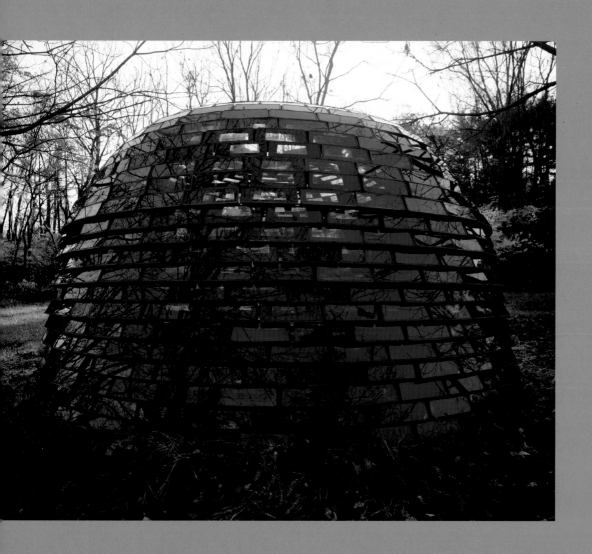

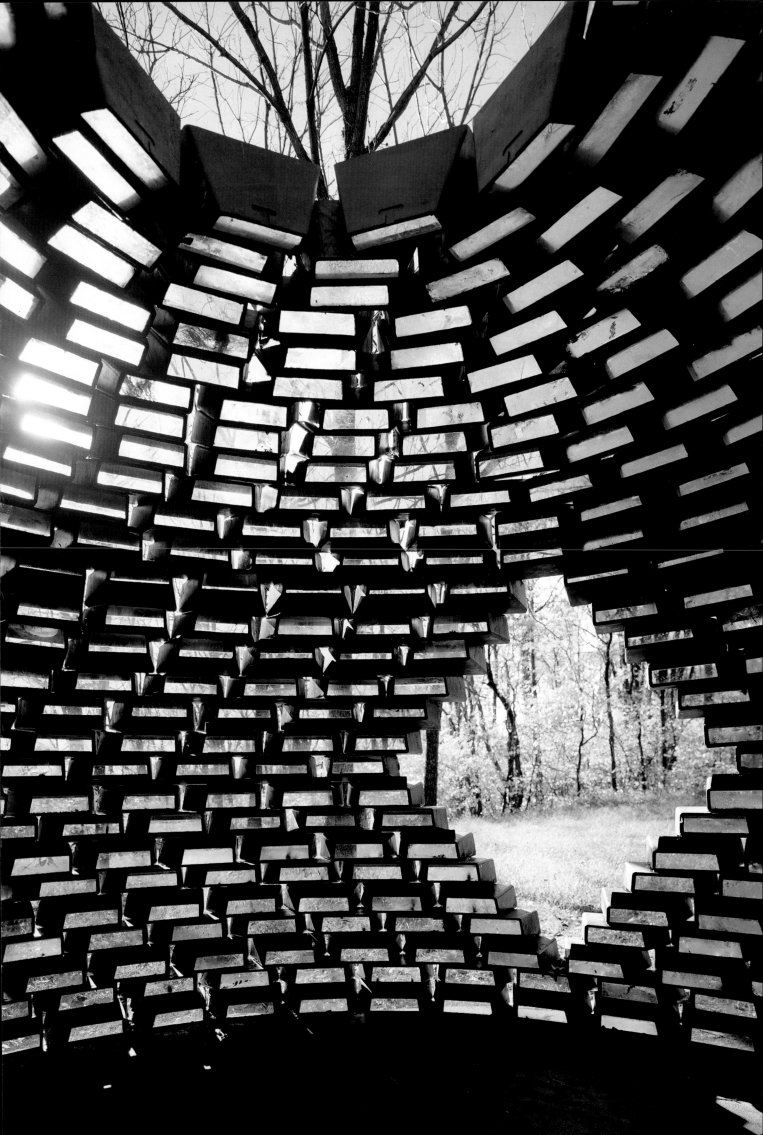

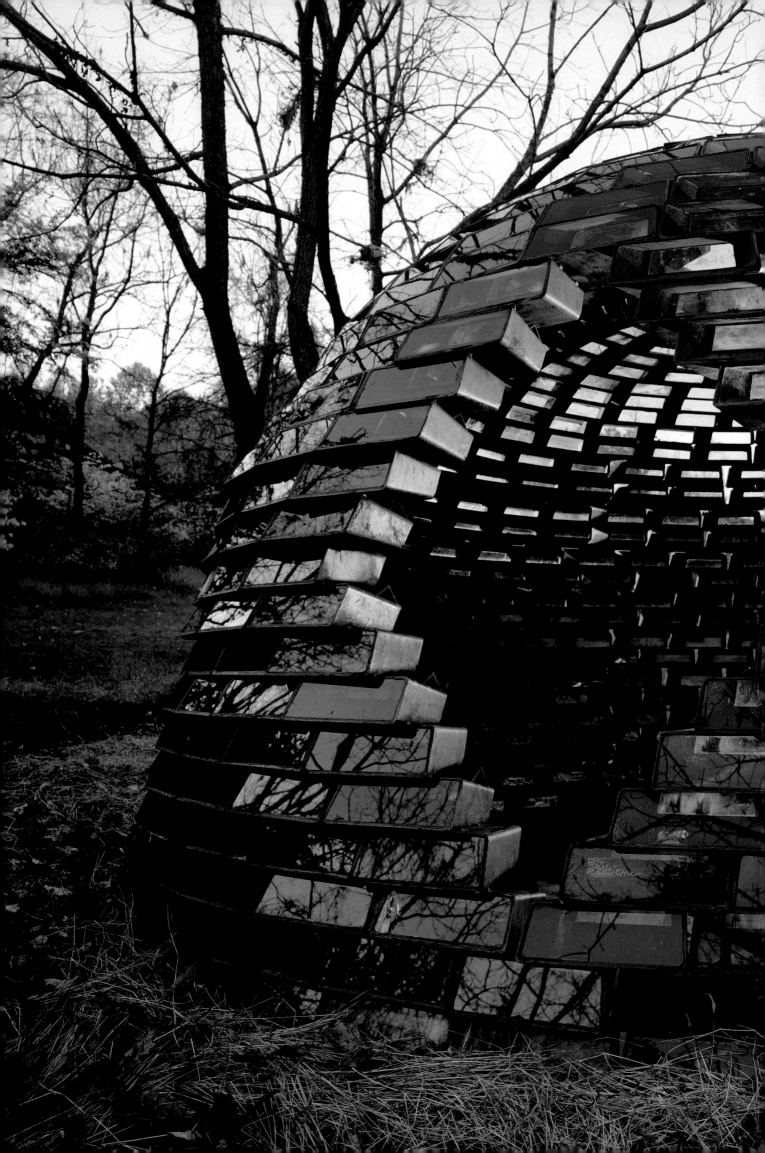

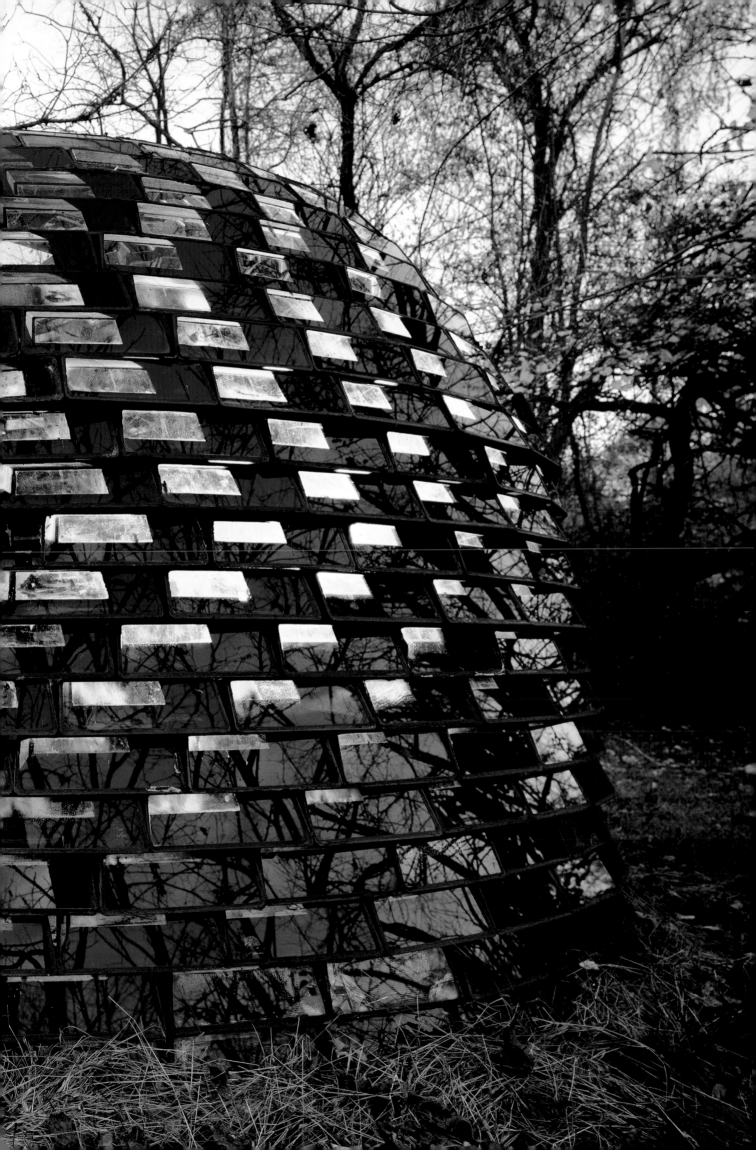

Paddle
Sculptures

"The space between the mental, emotional and physical is often a difficult one to cross. Many of my concepts are perfected and mature as ideas. Often I can convey an idea through words, drawings and gestures better than I can by actually making the piece. The actual ity of the piece often competes with the idea of it. Maybe some pieces exist better simply as ideas."

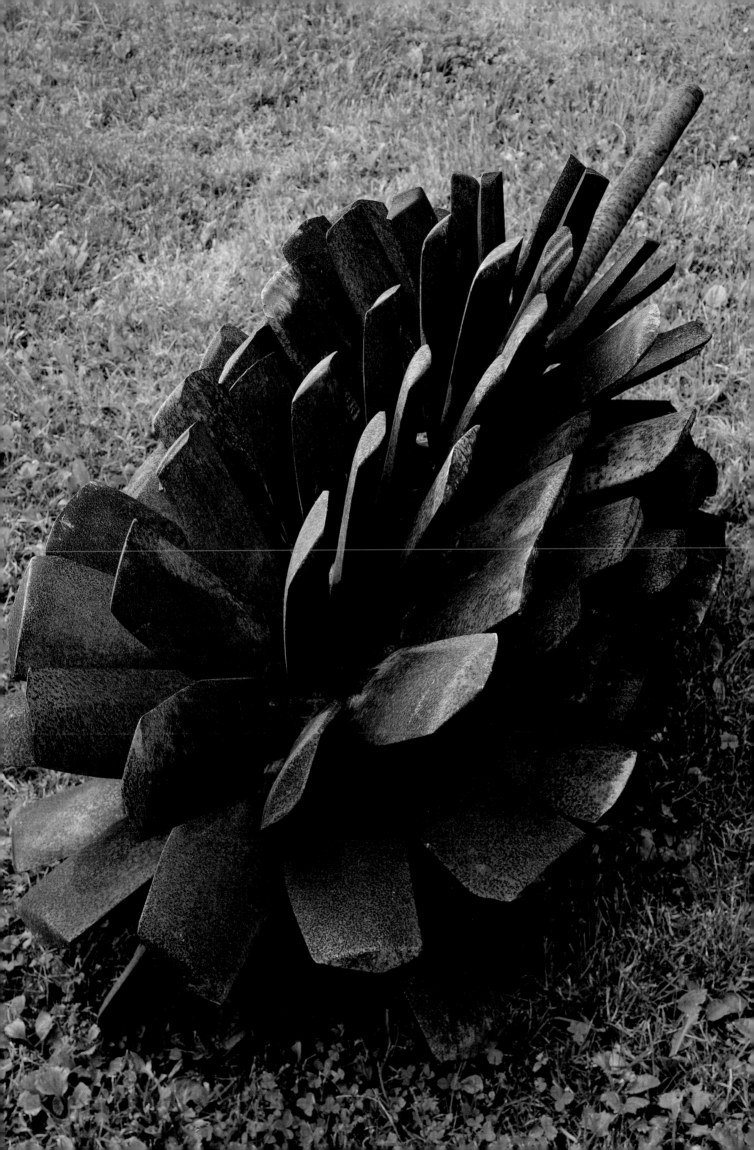

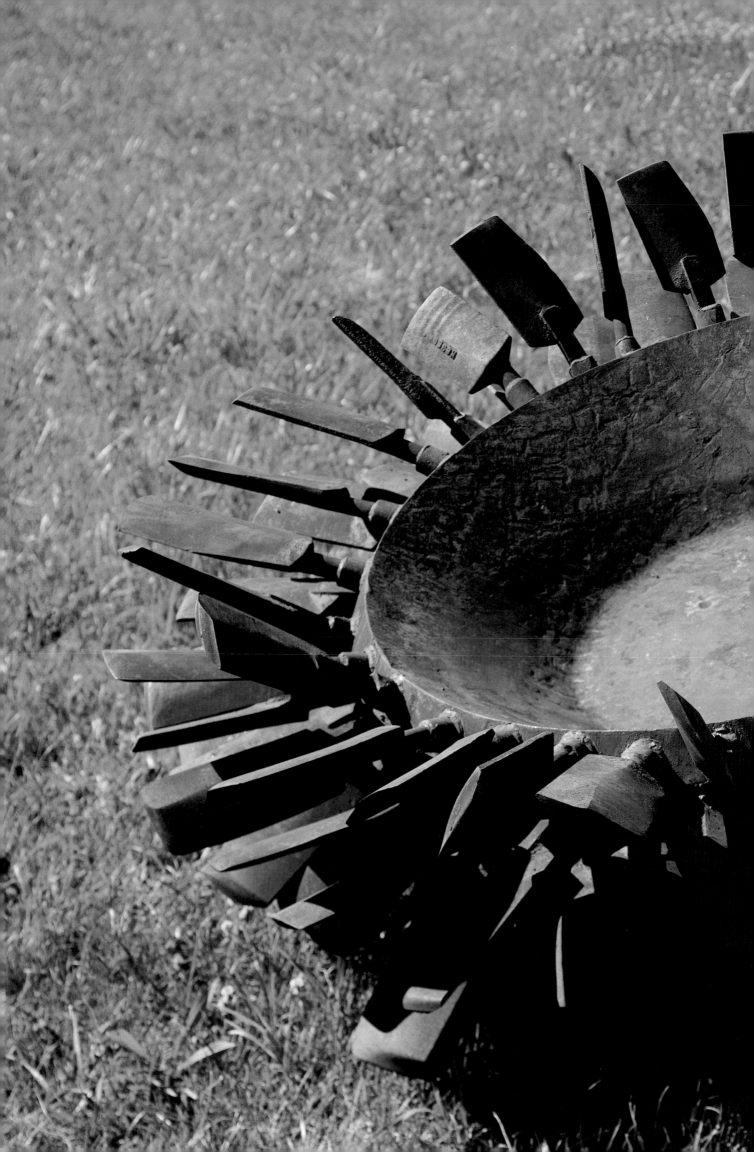

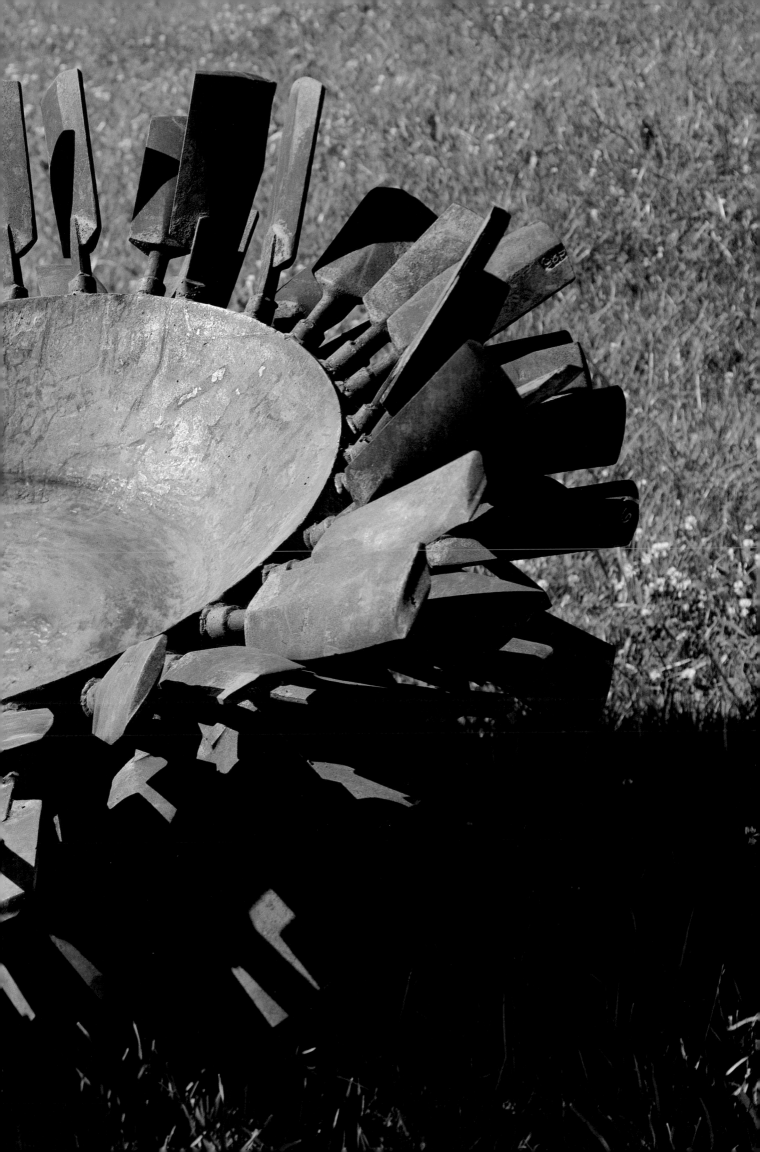

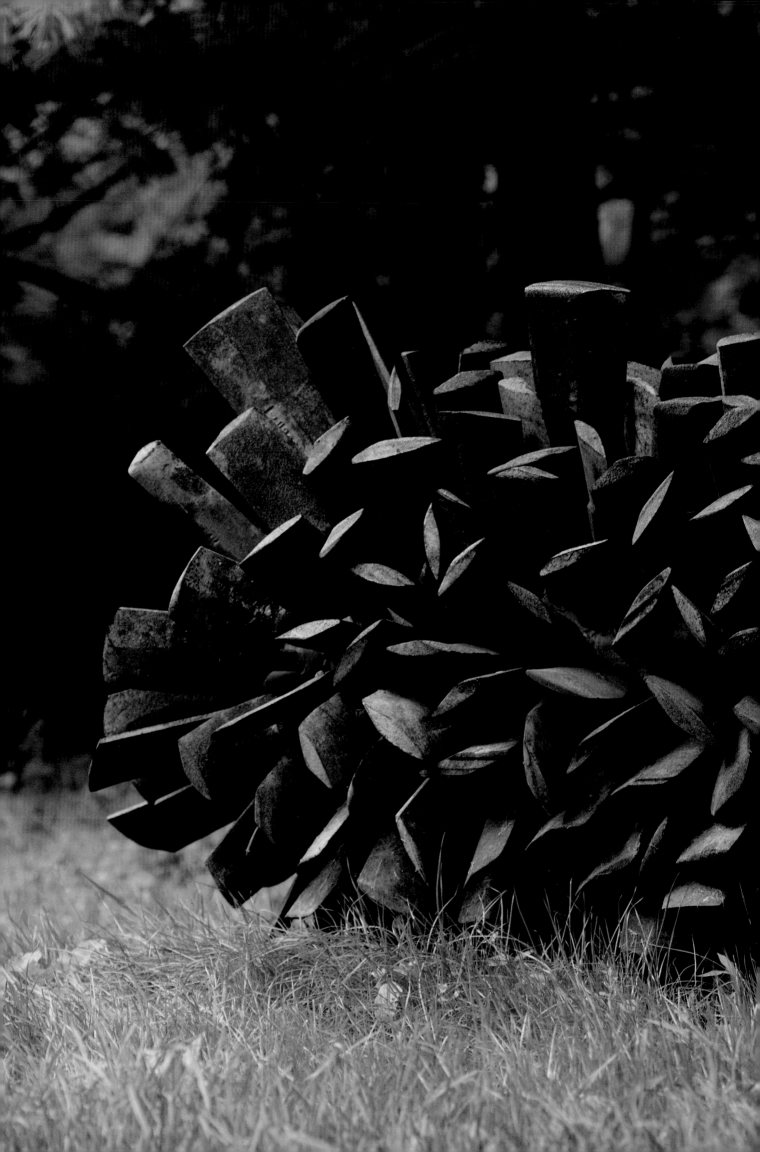

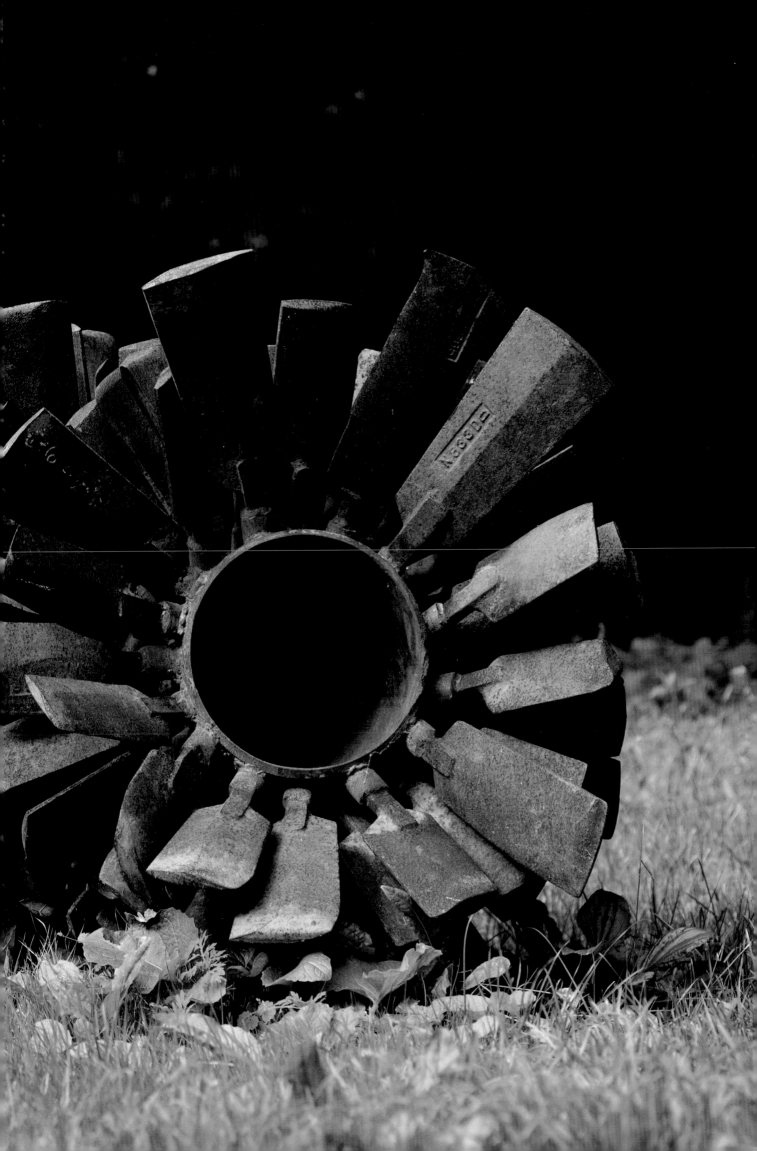

B o n e
S c u l p t u r e s

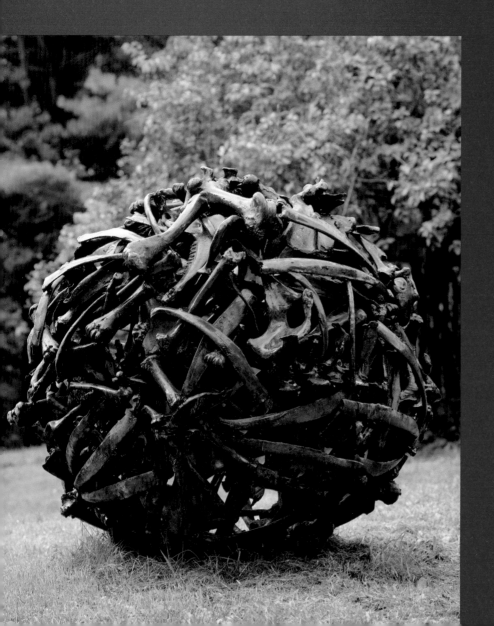

"*The bone is a structural element…when you strip the animal down, you're left with a bone. It's a structure and there's a beauty to the strength of the structure… each shape and transition of shape is created for a structural reason. The beauty in it is the architecture of the body. I use the bones for their beauty…not their death association… although I can't ignore that. The bones are actual bones from actual living animals. It gives the sculpture another layer of reality. The materials are bronze and bone. I like the 'in your face' confrontation. It takes it away from being decorative and closer to being real…one step closer to being real.*"

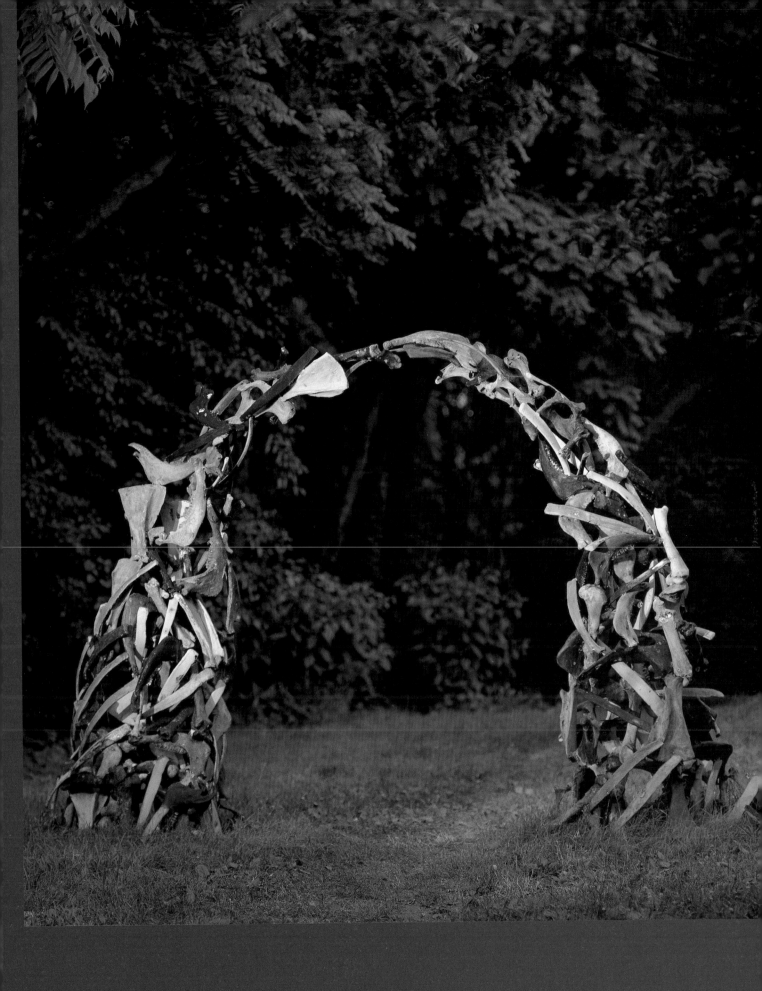

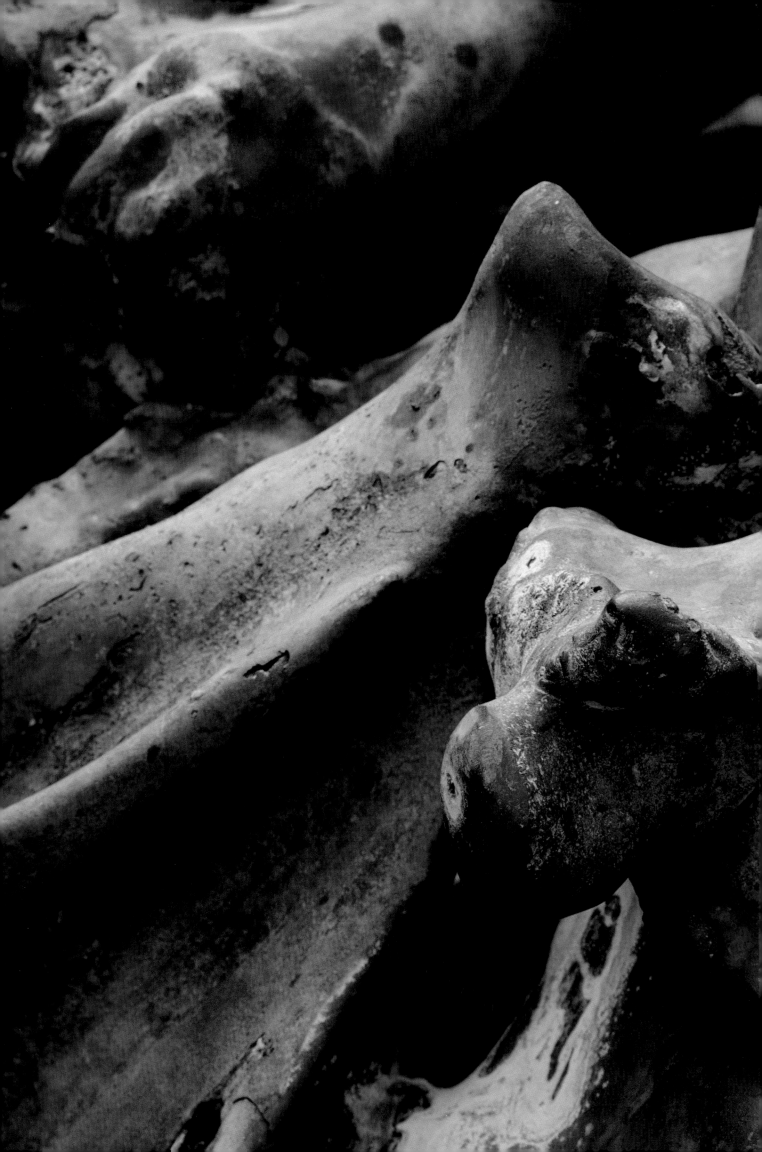

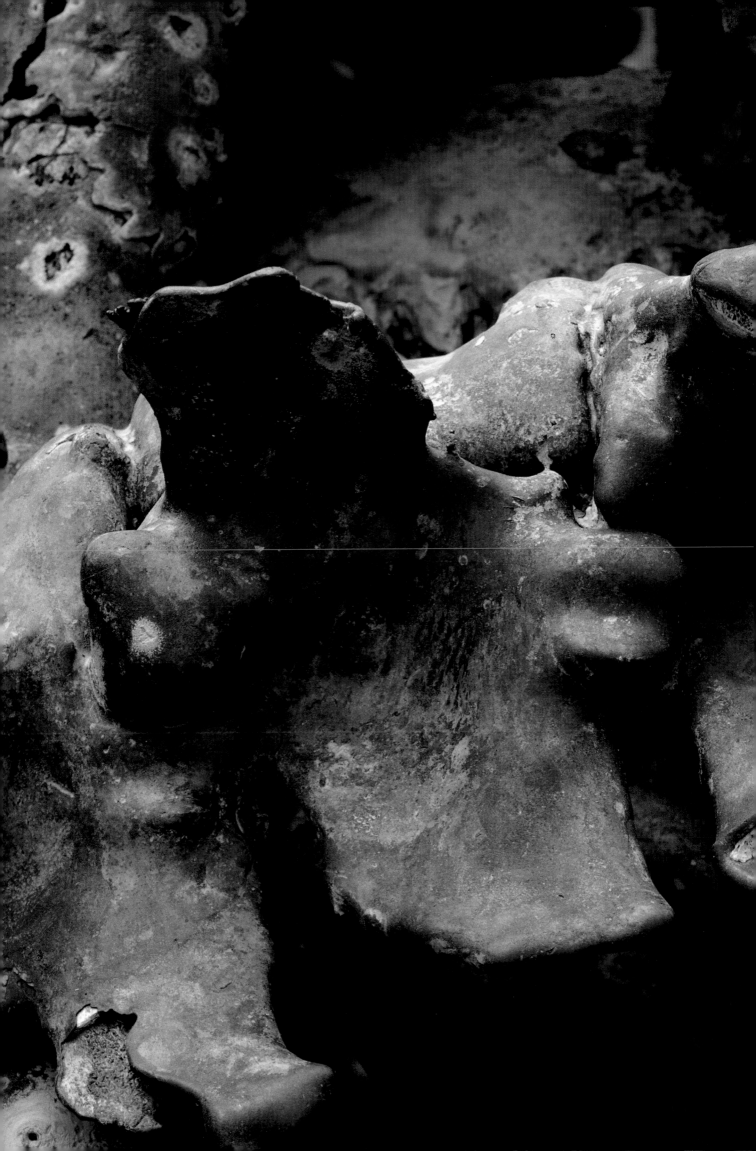

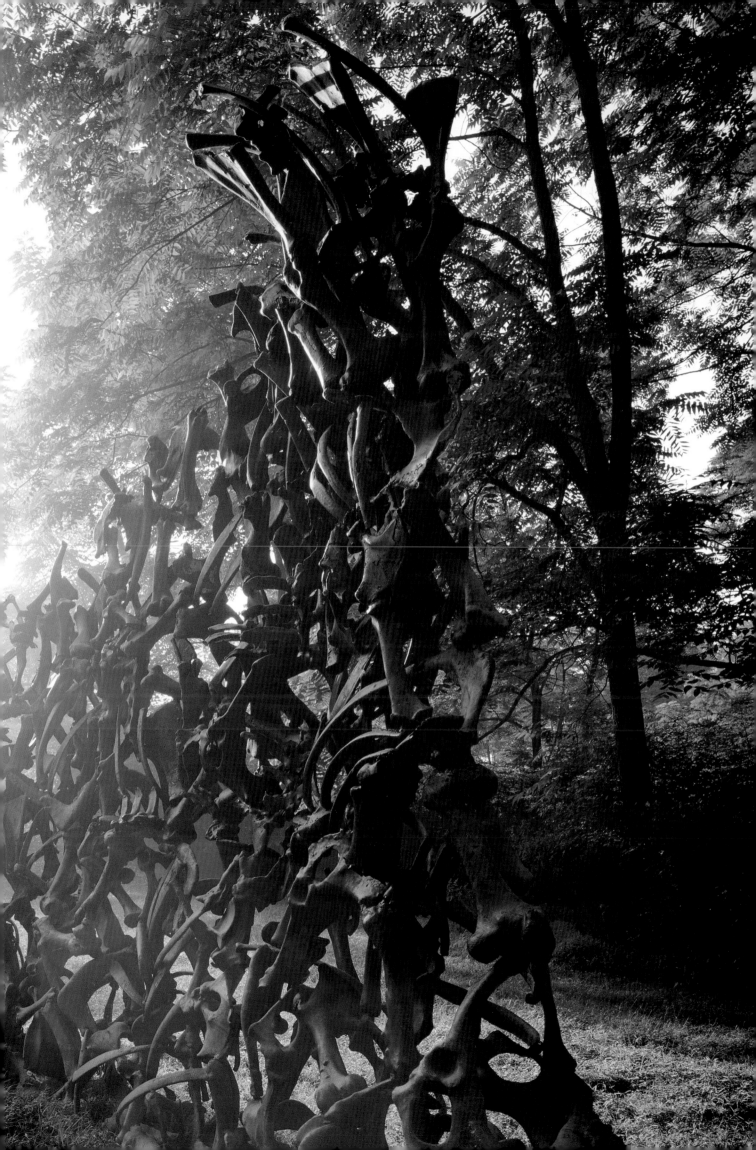

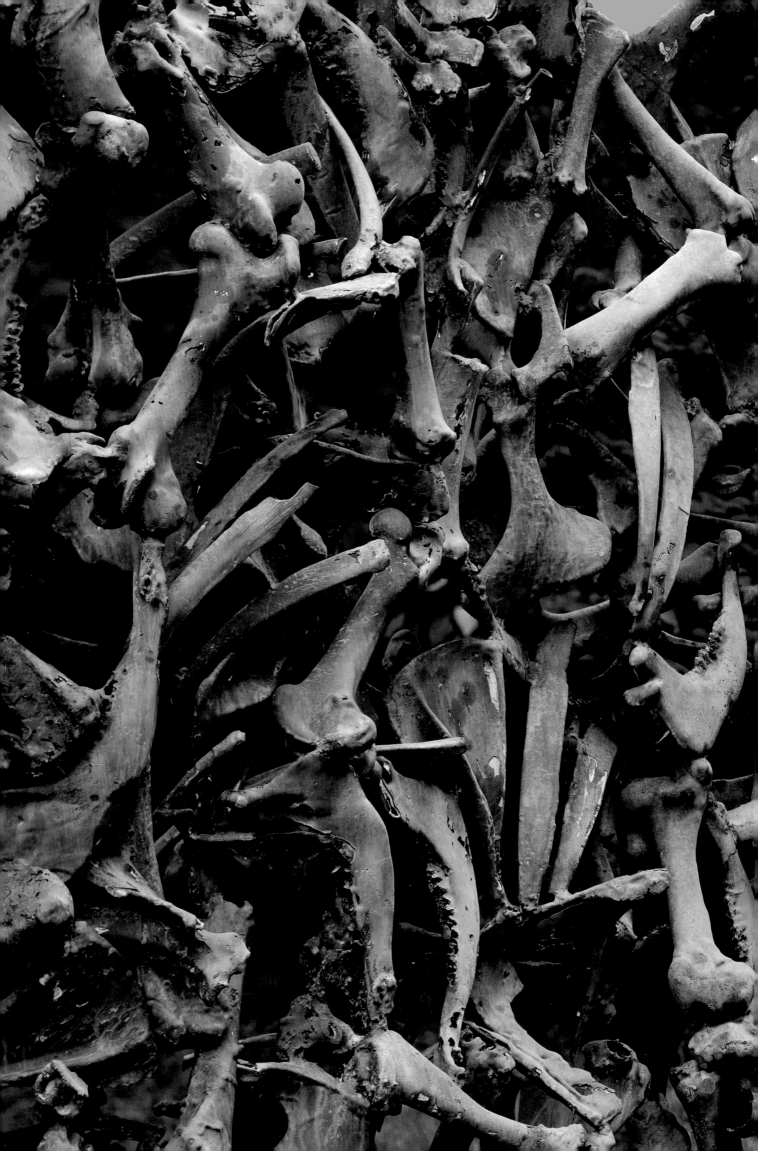

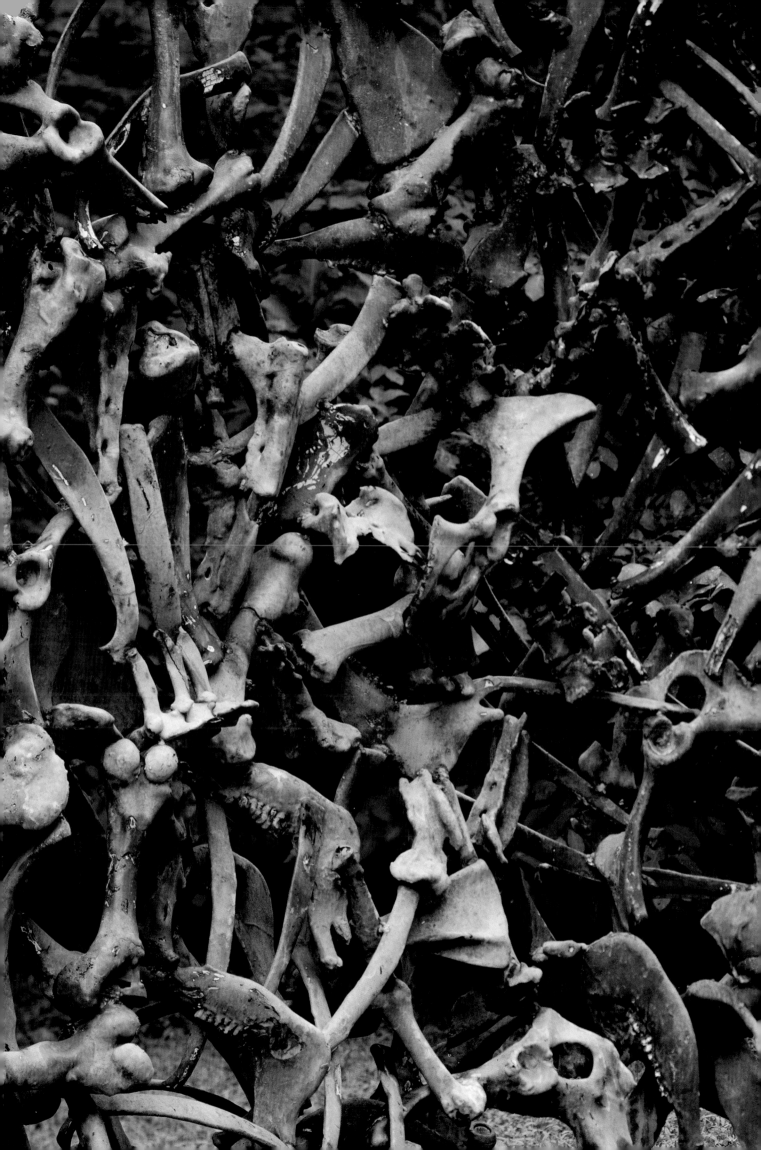

Steel
Sculptures

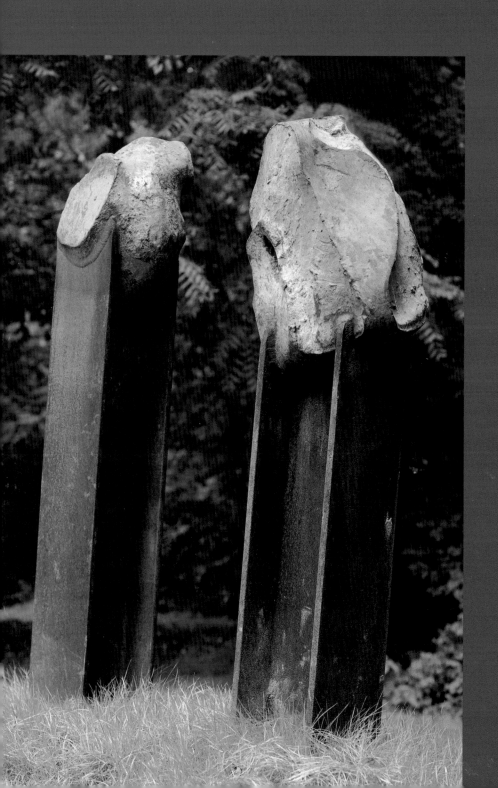

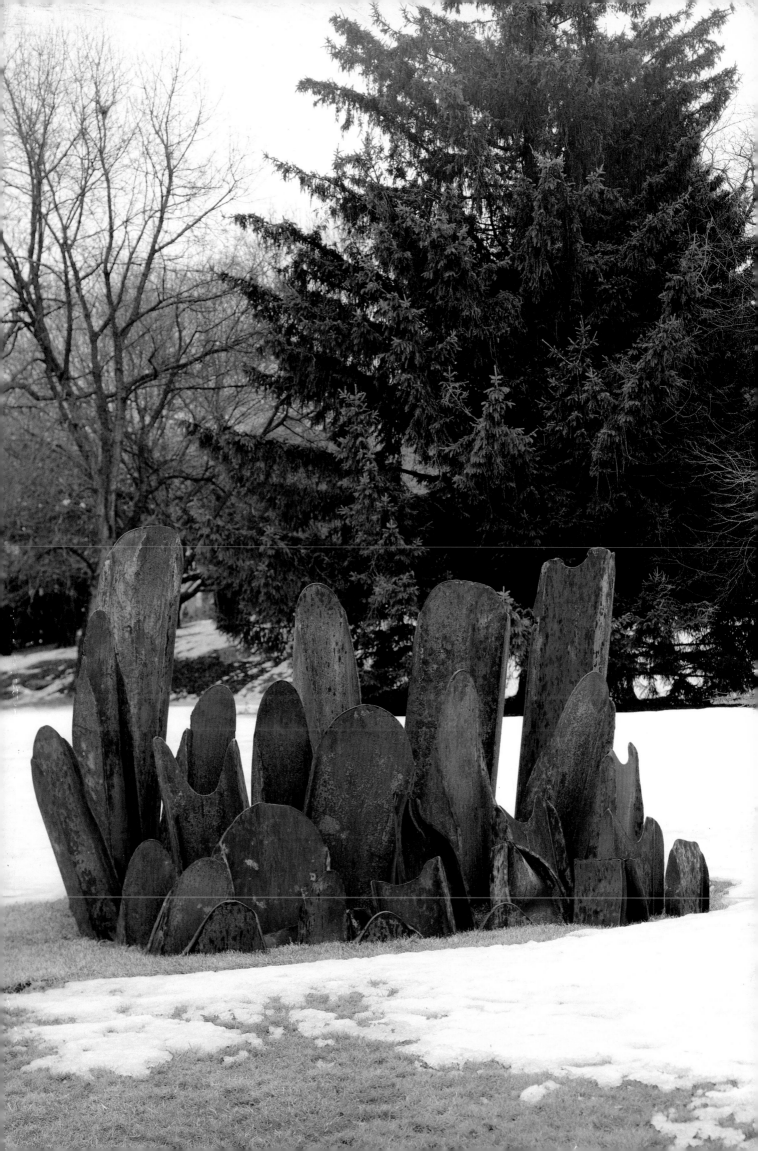

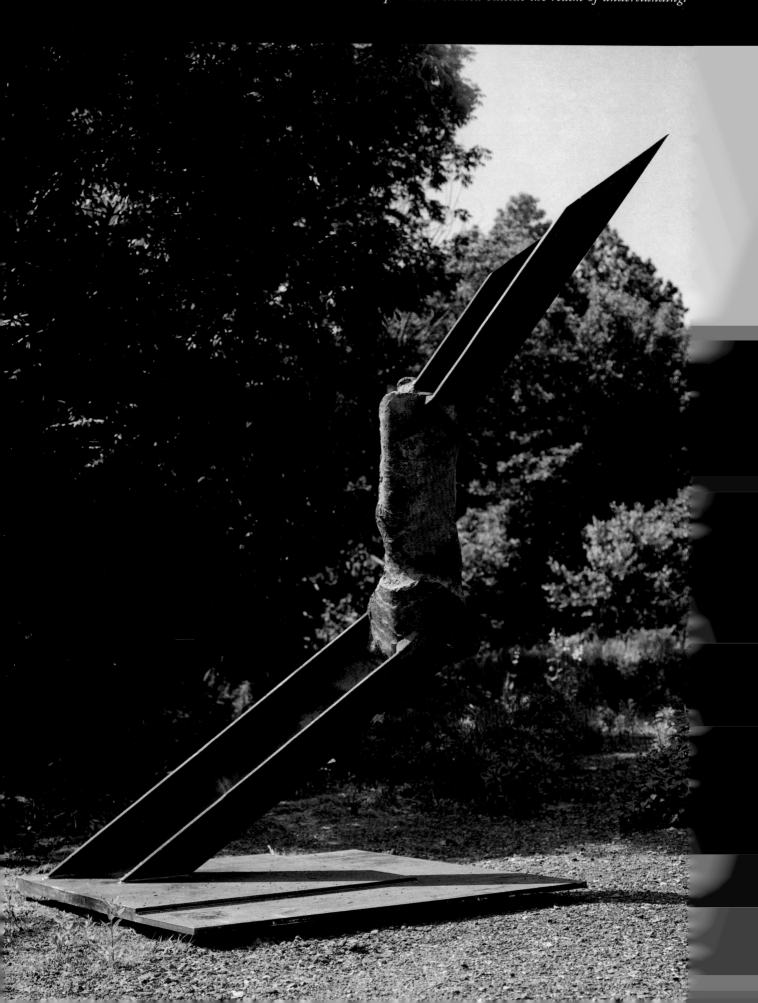

Hopefully I will learn something about myself and the piece that will solve the mystery in the work that eluded me. That is the motivation that I have to make a piece. I feel that my best pieces are created outside the realm of understanding."

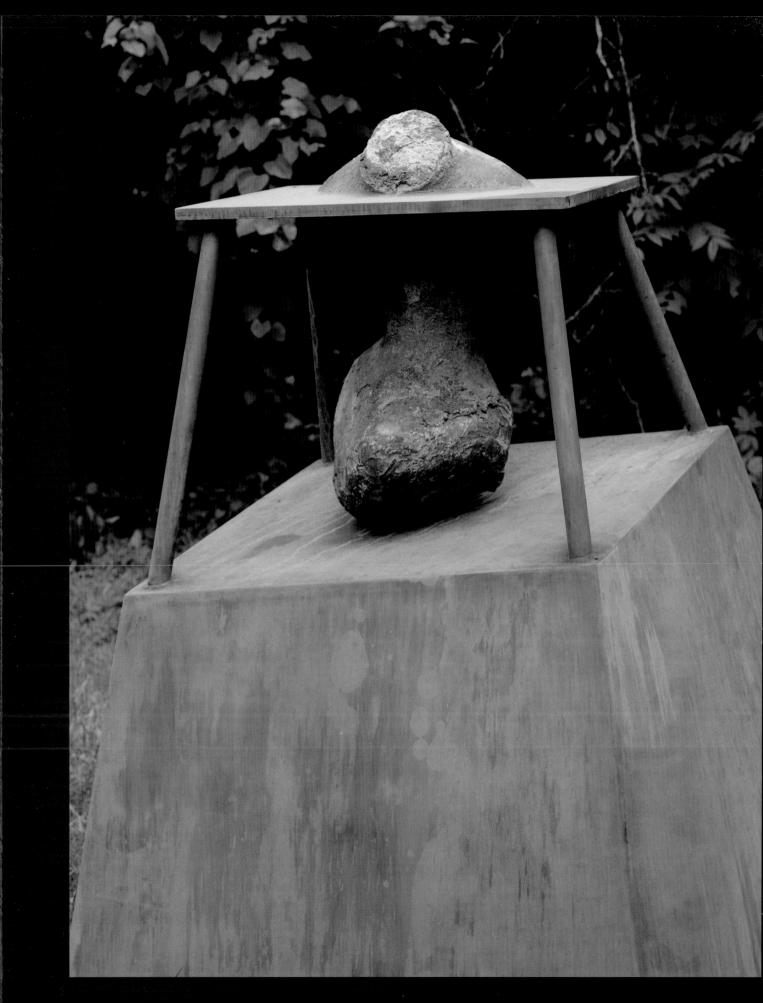

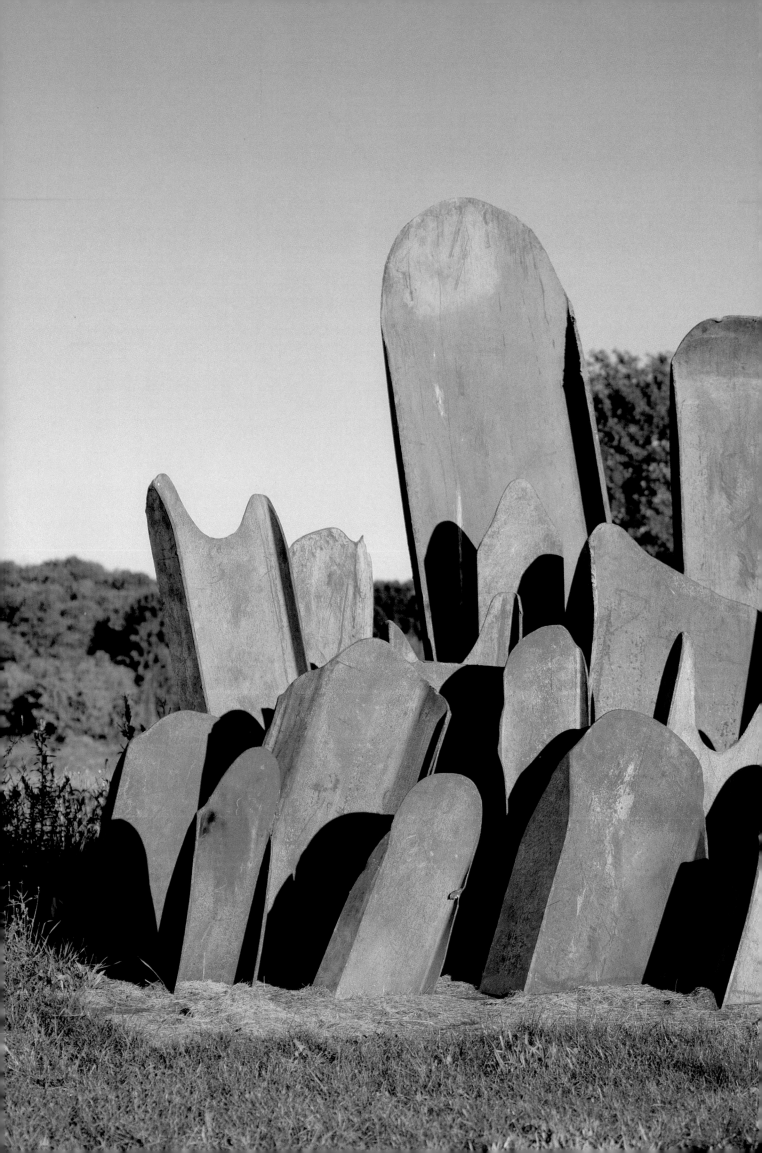

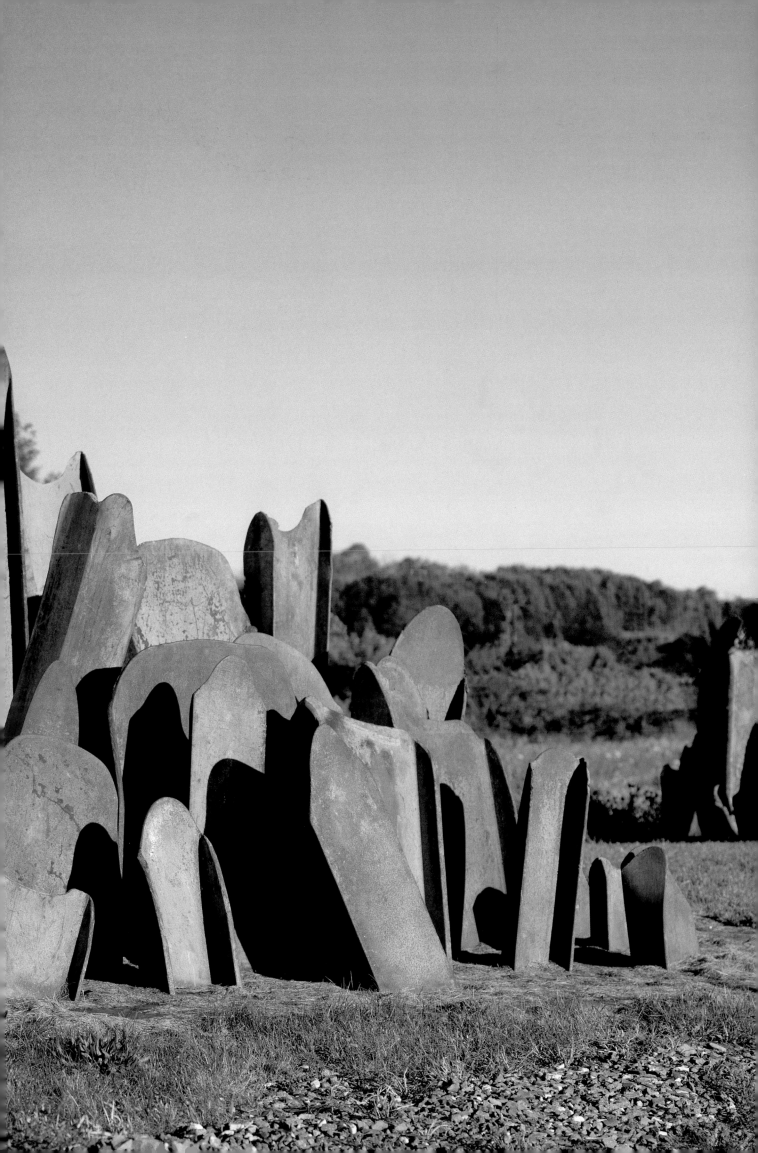

"If we can see patterns better, we are more able to understand the essence of what it is we are looking at."

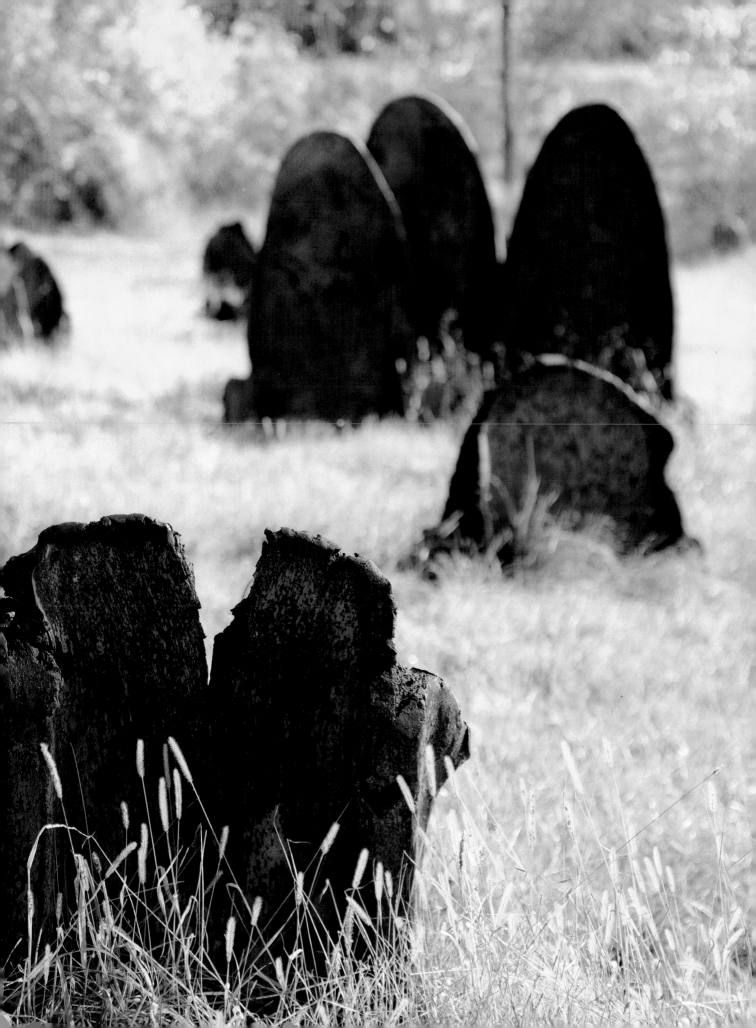

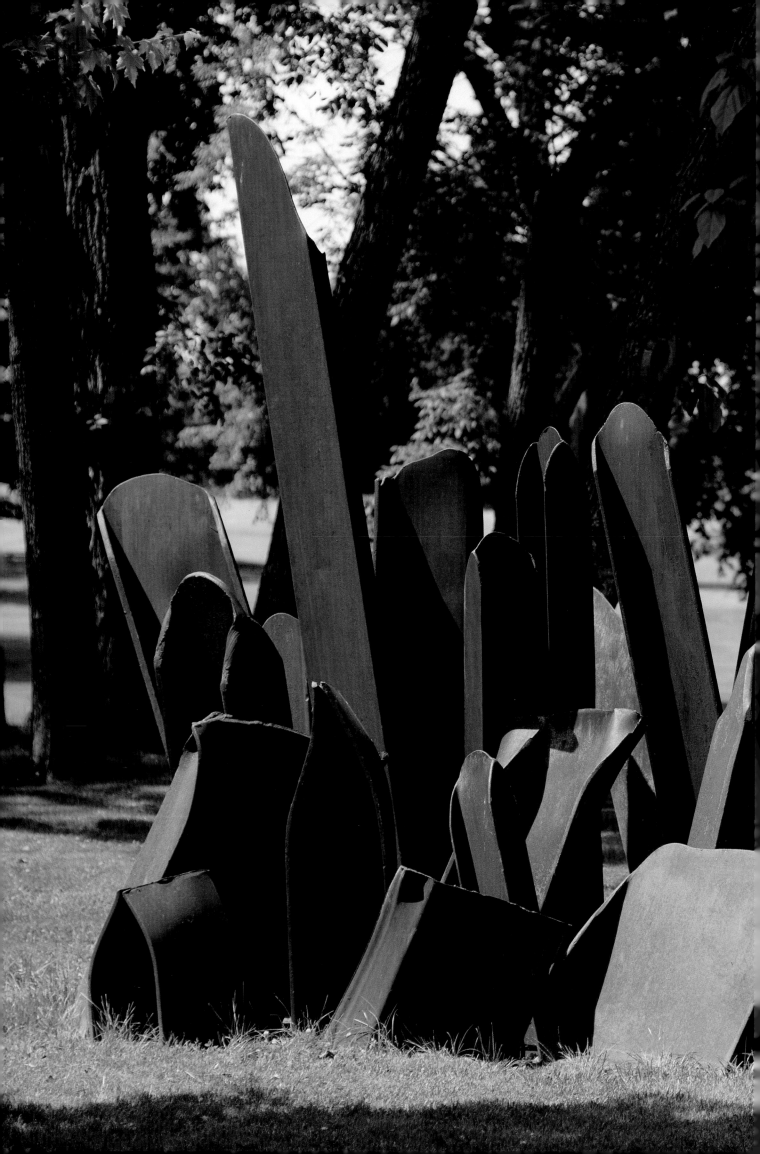

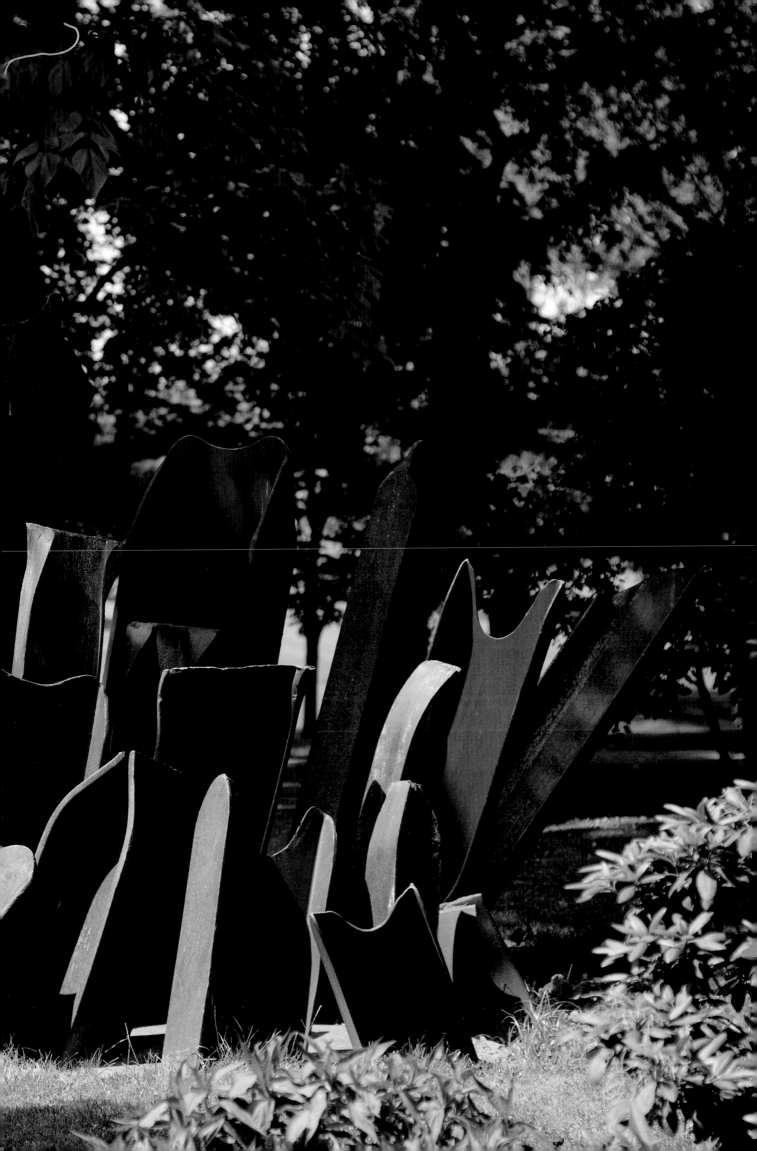

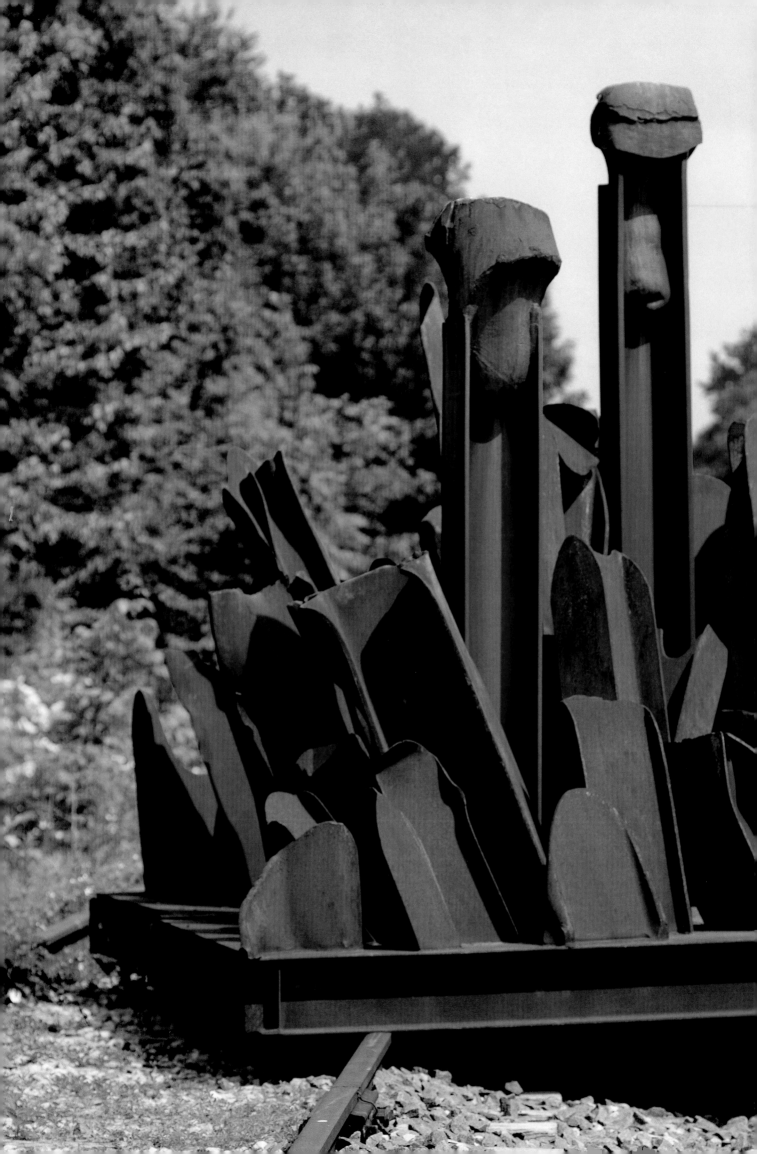

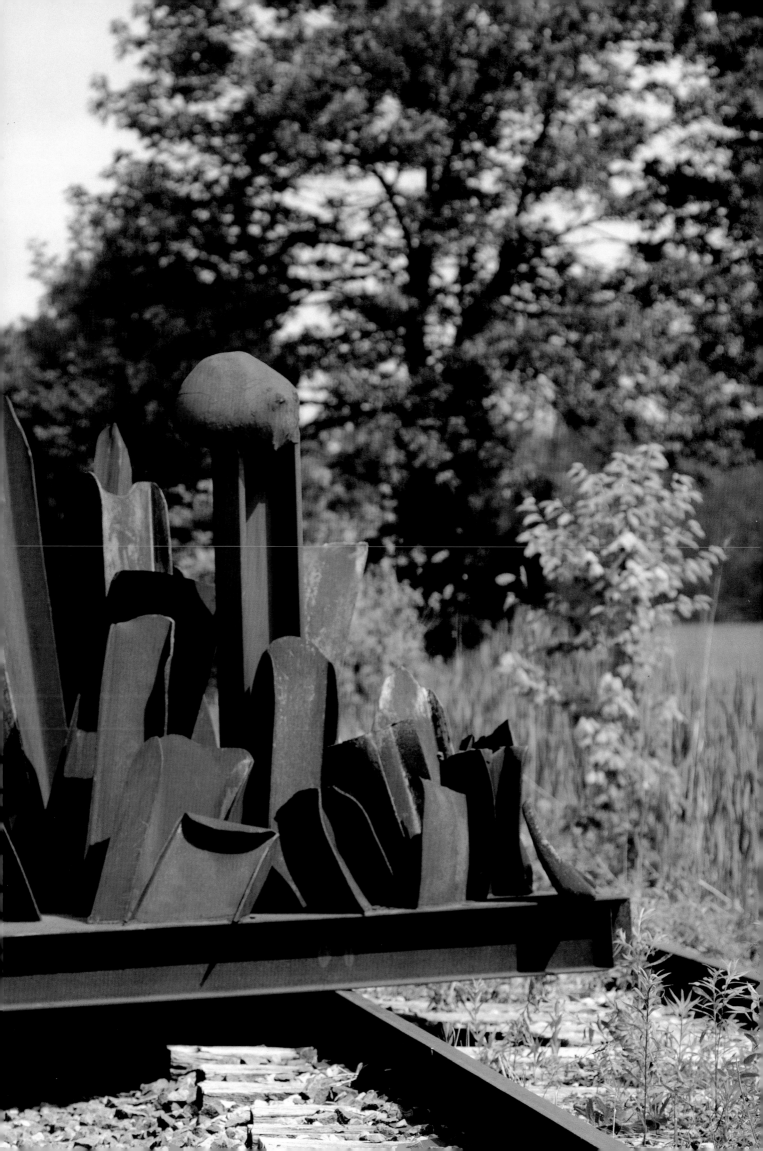

The work pictured in this book was created in two years with a lot of help from several talented people. *Densaboru Oku, Daisuke Shintani, Tom Considine* and *Steve Luke* made the transition from master glass workers to master bronze craftsmen almost overnight. *Oku* did the welding. *Shintani* melted the bronze. *Considine* did the mold and wax work and *Luke* did the patinas. And they did it well. I want to thank *Isaac Kennedy* for his skillful metal chasing and *Peter Lewis* for his positive energy. Other people that helped were *Bob Sklodowski, Bob Myers* and *Joe Howard*.

The steel sculptures were created with the support and guidance of *Philip* and *Muriel Berman*. They were engineered by *Gary Hellerman* and diligently welded by *Dan Fetterolf* and fabricated at *Prodex, Inc.* The metal was provided by *Easton Iron and Metal, Inc.* and *Waylite Corp.*

The bones for the Wall, the Arch and the Ball were provided by *Brent Gouldey* and the *North American Bison Cooperative*.

The tank windows for the Adobe were donated by *Jay Wechsler*. The glass tubes for the water glass installations were donated by *Friedrich and Dimmock, Inc.*

This book was created by the talented team of *Chris Rose* and *Andy Rice*. I want to thank *Karen Lodge* for her insightful essay and for seeing the entire project through to completion.

The *Bentley Gallery, Peyton Wright Gallery* and the *Philip and Muriel Berman Museum of Art at Ursinus College* provided support for this publication.

This book is dedicated to my father.

Steve Tobin

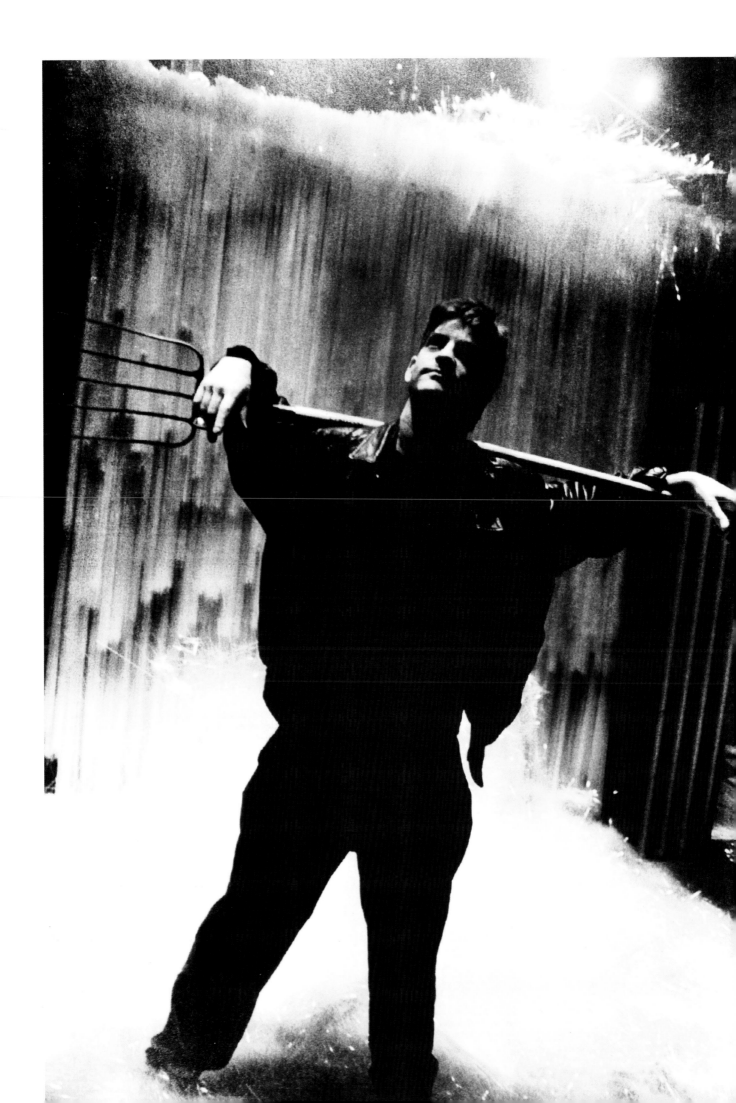

Steve Tobin

Born	Philadelphia, Pennsylvania, *1957*
Resides	Bucks County, Pennsylvania
Education	Tulane University, BS Mathematics, *1979*

Selected Solo Exhibitions and Installations

1995 Philip and Muriel Berman Museum of Art at Ursinus College, Collegeville, Pennsylvania, (Catalog)
Peyton Wright Gallery, Santa Fe, New Mexico
Bentley Gallery, Scottsdale, Arizona
1994 Sanske Gallery, Zurich, Switzerland
Habatat Gallery, Boca Raton, Florida
1993 Retretti Museum, Finland (Catalog)
1992 Carpe Diem Gallery, Paris, France (Catalog)
Lehigh University Art Museum, Bethlehem, Pennsylvania (Catalog)
1991 Habatat Gallery, Boca Raton, Florida
1990 Sanske Gallery, Zurich, Switzerland
1989 Holsten Gallery, Palm Beach, Florida
1988 Moore College of Art and Design, Philadelphia, Pennsylvania (Catalog)
1987 Axis Gallery, Tokyo, Japan
Tazawa Gallery, Kyoto, Japan
1986 Lavaggi Gallery, New York, New York
1982 Gallery 10, New York, New York
1980 Spring Street Gallery, New York, New York
1979 Bienville Gallery, New Orleans, Louisiana

Selected Group Exhibitions and Installations

1994 "*Waterworks,*" Palm Beach Community Museum, Palm Beach, Florida
Allene Lapides Gallery, Santa Fe, New Mexico
Robert Morris Gallery, New York, New York
1993 "*Glass Installations,*" American Craft Museum, New York, New York
"*From Our Vault,*" Wustum Museum, Racine, Wisconsin
1991 "*Le Verre,*" Lespace Duchamp Villion, Rouen, France
1990 "*Glass Doesn't Grow in the Forest,*" St. Augustine Chapel, Belgium
1989 "*Glass America,*" Heller Gallery, New York, New York *(1990, 1991, 1992, 1993)*
1986 "*New American Glass Focus 2,*" Huntington Museum of Art, Huntington, West Virginia
1983 "*Southern Glass,*" Roanoke Museum of Fine Arts, Roanoke, Virginia
1979 "*Louisiana Glass,*" Alexandria Museum, Alexandria, Louisiana

Selected Bibliography

1994 Michelle Conlin, The Philadelphia Inquirer (Nov. 6)
Mary Shaffer, "*Philip and Muriel Berman Workshop,*" Maquette Magazine (February)
1993 Holland Cotter, "*Glass Sculptors Whose Work Transcends Craft,*" New York Times (June 18)
Nancy Princenthal and Janet Kardon, "*Glass Installations,*" Catalog Essays, American Craft Museum
Grace Glueck, "*Gladly Glassy-Eyed at the American Craft Museum,*" The New York Observer (June 14)
M.W. "*Treasure Trove,*" Time Magazine (August 2 International)
Art in America, (December 1993)
Catherine Vaudour, "*L'Art du Verre,*" (Paris 1993)
1992 Catherine Vaudour, "*Le Verre*" Nues Glas Magazine (February cover)
Colette Save, "*Le Verre Superstar,*" L'atelier Magazine (January)
1990 Maria Porges, "*Steve Tobin: Breaking the Rules of Glass,*" Art Today (August)
Leo Bogman, "*Glas van Drinkbeker tot Kunstobject,*" Belgium
1989 Richard Torchia, "*Steve Tobin: Glass and Environment,*" Neus Glass Magazine (September cover)
1988 Lenore Chen, "*Essence of the Frail,*" A.M. Magazine (July 8)
1984 Roslyn Seigal, "*Fellowship Glass,*" The New York Times (June 23)

Selected Permanent Collections

State Museum, Harrisburg, Pennsylvania
Gratz College, Philadelphia, Pennsylvania
Philip and Muriel Berman Museum of Art at Ursinus College, Collegeville, Pennsylvania
American Glass Museum, Millville, New Jersey
Coca-Cola Corporation, Atlanta, Georgia
Stephane Janssen Collection, Santa Fe, New Mexico
Lowe Art Museum, Miami, Florida
New Orleans Museum of Art, New Orleans, Louisiana
Philadelphia Museum of Art, Philadelphia, Pennsylvania
Musée des Arts Decoratifs, Lausanne, Switzerland
American Craft Museum, New York, New York
The White House, Washington D.C.
King Faisal's Palace, Saudi Arabia
Finair, Helsinki, Finland
America Center, Helsinki, Finland
Retretti Museum, Savonlinna, Finland

List of Plates

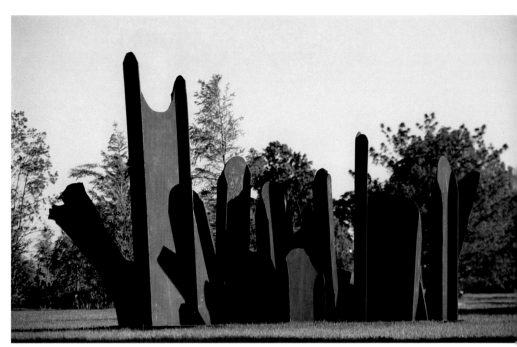

Photo by: *Ricardo Barros*

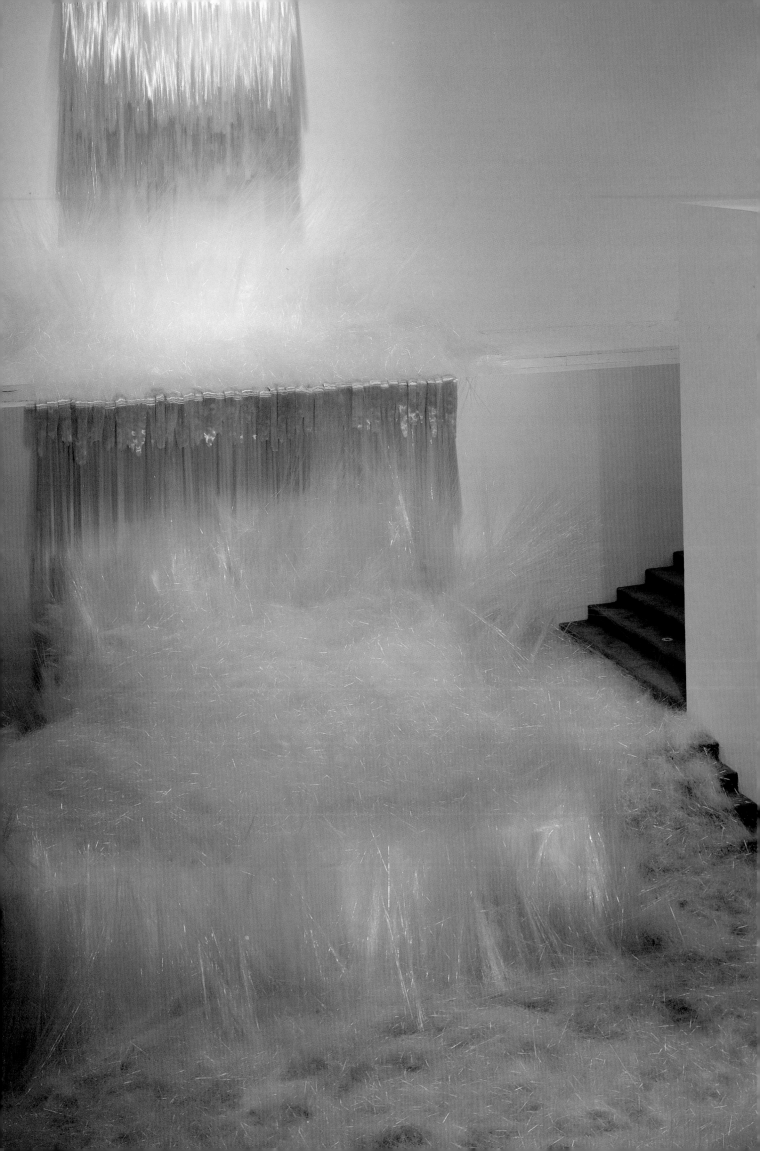